POSTCARD HISTORY SERIES

Ocean Grove

IN VINTAGE POSTCARDS

D1305644

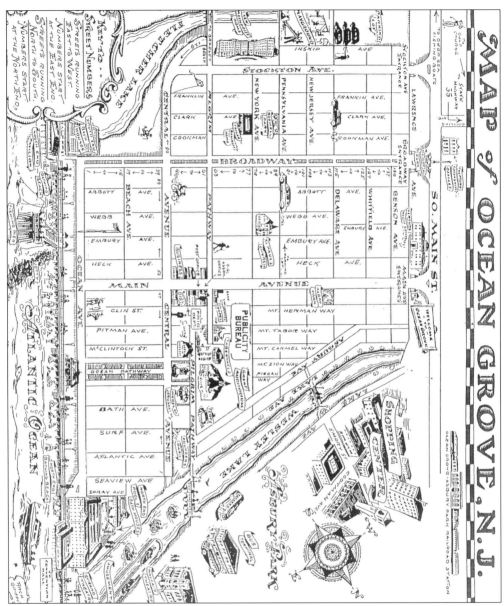

This map of Ocean Grove was designed by Archie Griffith, an artist who created many varied and unique signs and programs for the Ocean Grove Camp Meeting Association. Examples include the sheet music of the "Ocean Grove Ushers' March," with 120 ushers' faces as notes; the annual Ushers' Christmas card; and many hotel room and fire escape diagrams.

POSTCARD HISTORY SERIES

Ocean Grove

IN VINTAGE POSTCARDS

Wayne T. Bell and Christopher M. Flynn

ARCADIA

Copyright © 2004 by Wayne T. Bell and Christopher M. Flynn
ISBN 0-7385-3501-X

First published 2004

Published by Arcadia Publishing,
an imprint of Tempus Publishing Inc.
Portsmouth NH, Charleston SC, Chicago,
San Francisco

Printed in Great Britain

Library of Congress Catalog Card Number: 2003115046

For all general information, contact Arcadia Publishing:
Telephone 843-853-2070
Fax 843-853-0044
E-mail sales@arcadiapublishing.com

For customer service and orders:
Toll-free 1-888-313-2665

Visit us on the Internet at www.arcadiapublishing.com

Acknowledgments

Many people opened their homes and offered a chair at the kitchen table for us to inspect their card collection. The cards were proudly displayed four to a page in crystal-clear polypropylene photograph pages.

Our profound thanks and gratitude go to the following persons who graciously allowed us to borrow their cards and pictures for one year until the galley proofs were received from the publishers. This book on postcards would not have been possible without their contribution.

William Bailey	William Knight
Kevin Chambers	William Kresge
Estate of Rose C. English	Martha Rakita
Helen Ford	Mary Randall
Susan Goodman	Susan Roach
Estate of Archie Griffith	Judy Ryerson
Gloria Hehn	Dr. Dale Whilden
Steven Hirt	Andrew Wilson
Sarah T. Holme	Historical Society of Ocean Grove

Others who assisted in the editing, photographing, and manuscript preparation are as follows:

Cindy Bell	Calvin and Karen Jenkins
Shirley Bell	Judy Kaslow
Cathleen E. Flynn	Beverly and Alan Williams
Kylene Jenkins	

Thanks also go to Susan Jaggard and Pam O'Neil at Arcadia Publishing.

4

CONTENTS

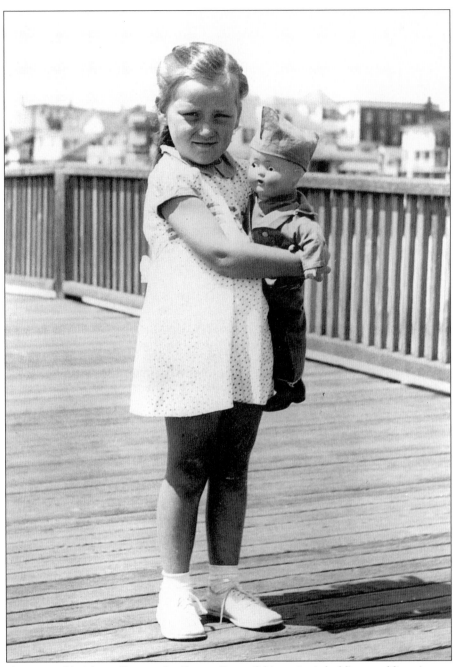

This five-year-old girl standing on the Ocean Grove fishing pier is holding a soldier given to her by her aunt Catherine Goomaat. The girl's sister Bette Lou Bakelaar had the matching sailor. The gift of a doll would set in motion a 50-year collecting urge that now fills two homes with a wide range of dolls, miniatures, colored-class chickens, children's books, postcards, and other items. Judy married her soldier boy in 1962 and still continues to collect with his help. Her collection of over 5,000 postcards of the Jersey Shore was made available to us. This book would not have been possible without this resource. We dedicate this book to Judy Ryerson as a thank-you for her generous gift and support on this project.

INTRODUCTION

In 1869, the community of Ocean Grove was chartered by the state of New Jersey as a camp meeting association, with a board of trustees consisting of 13 ministers of the Methodist Episcopal Church and 13 laymen. The development of the camp meeting grounds and the religious program was rapid, well managed, and most importantly, successful. The 1,971 lots, each 30 feet by 60 feet, were sold to interested persons, with an attached lease contract of $10.50 per year for 99 years, subject to renewal. Ocean Grove lots still carry the original lease contracts.

At one time, there were more than 700 tents on individual lots. Today, there are only 114 tents available for lease from the Ocean Grove Camp Meeting Association, from May 15 to September 15. These tents surround the Great Auditorium, a 9,000-seat wooden structure built in 1893–1894 at a cost of $70,000.

Ocean Grove is a Victorian-planned 19th-century community that is unique for many reasons. One of its most unusual restrictions was the prohibition of carriages and, later, automobiles on the streets of Ocean Grove on Sunday, the Christian Sabbath. This rule was enforced for 117 years.

The visual history of Ocean Grove is captured in photographs, postcards, and even film. The number of persons who visited for a weekend or for one, two, or three weeks or even the entire season is difficult to accurately measure. Some records are available, such as bridge tolls, railroad tickets, and attendance at religious services. The numbers vary from 300,000 to 500,000 per year depending on the season and the programs. Visitors mailed or carried a lot of picture postcards back home.

What began as a religious summer tenting camp meeting ground eventually evolved into a year-round close-knit community with a present population of 5,000. In 1976, Ocean Grove was designated a National and State Historic District.

Postcard collecting is considered the second biggest hobby in America, eclipsed only by stamp collecting. Postcards provide not only a visual account of the past but also a brief record of communications between sender and receiver. Although supposedly not of major importance, the messages written on the cards offer a quick glimpse into everyday occurrences in the lives of ordinary people. Collecting these cards is a fascinating hobby. Deltiologists, who collect and study picture postcards, tend to categorize cards by eras or times when changes occurred as the result

of new government regulations or economics. Picture cards are generally divided into the following time periods:

The first U.S. government issued postal card, 1873; second issue, 1875.

The pioneer (1893–1897), the first picture cards issued by the U.S. post office for sale at the World's Columbia Exposition in Chicago.

The private mailing card (1898–1901), bearing the words "Private Mailing Card."

The postcard era (1901–1907), a term postcard authorized on privately printed cards, with a message to appear on picture side only.

The divided-back era (1907–1914), with writing permitted only on the left portion of the back of the card back; embossed cards were introduced.

The white-bordered era (1915–1930), a white border around the picture, used as a cost-saving measure.

The linen era (1930–1944), a high-rag content card stock, with a textured feel and colored inks.

The chrome, or photograph, era (1945–present), glossy color photographs.

Other paper collectible historical images include stereopticon views, souvenir foldout packets, small booklets, trade and rate cards, and plain canceled letters with the Ocean Grove postmark.

The search for cards is an unending occupation that inevitably involves making new friends. Ocean Grove cards are many and greatly varied. A collector of Ocean Grove cards may specialize in a specific subject such as fire engines, street and aerial views, costumes, tents, comic images, hotels, interiors, animals, beaches, boats, or disaster scenes. The collection in *Ocean Grove* was selected based on condition and subject. Some cards are very rare; others are not so rare. A study of the pictures presented here will reveal changes that have occurred over time, particularly with respect to the trees, buildings, light poles, clothing, and vehicles. Although Ocean Grove scenes have changed, the vitality of the past has been captured.

One
THE NORTH END
AND NEIGHBORS

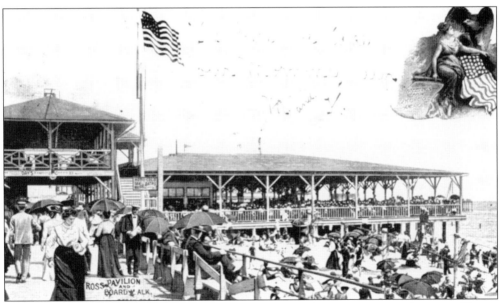

Postcards offer incredible snapshots of the past, as in this Arthur Livingston card, sent to Chester County, Pennsylvania, in 1903. The women and men stroll along the boardwalk, and not a bench in sight has room, except for the one that is broken. Livingston cards are recognizable by their trademark of an American flag, eagle, and female figure either on the front or the back of the card.

ROSS'
BATHING ESTABLISHMENT

—AND—

RESTAURANT,

FOOT OF WESLEY LAKE, OCEAN GROVE.

Hot and Cold Sea Water Baths.

BEST SUITS. PERFECT BEACH.

EXPERIENCED BATHING MASTERS.

MEALS AT ALL HOURS.

Ice Cream, Soda Water, Confectionery, Lemonade,
Ice Cream Soda, Fruit, Nuts, &c.

**Fancy Goods, Sea Shells, Novelties,
Buckets, Shovels and Children's Toys.**

ROSS'—— The oldest established, most con-
venient and popular resort on the
Coast.

FOOT OF WESLEY LAKE,

ADJOINING ASBURY PARK.

ASBURY PARK PRINTING HOUSE.

Bathing rights were first assigned to W.T. Street in 1871. In 1876, the concessions at the north end were transferred to Joseph Ross, who established Ross's Pavilion. In this trade card, produced by the Asbury Park Printing House, Ross featured many of the services that would be a part of Ocean Grove's north end: hot and cold seawater baths, dining, shopping, and rocking chairs.

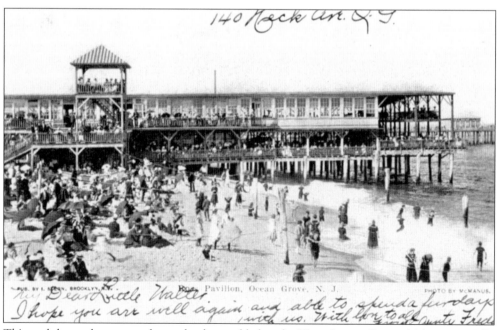

This card shows that a second story has been added to the Victorian pavilion, which was partially enclosed by glass. Both changes are the result of Ocean Grove's increasing popularity during this time period. Additionally, the glass afforded use of the facility during the spring and fall, when the weather might be less than perfect.

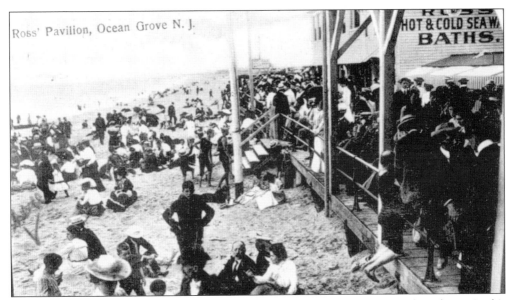

Joseph Ross's pavilion had a capacity of between 1,800 and 2,000 patrons and, as shown in this image, that number was a shoulder-to-shoulder census. Of note are the cast-iron boardwalk railing supports, manufactured by Bawden & Company of Freehold. Today, many of these original supports can still be found along the northern section of the boardwalk.

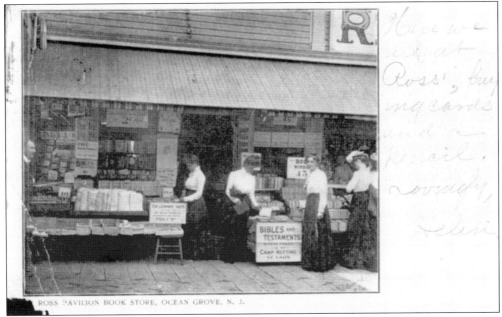

Helen, the woman who sent this card in 1903 to Allentown, Pennsylvania, purchased her postcards and pencils at the pavilion's bookstore, as is written on the front of this postcard.

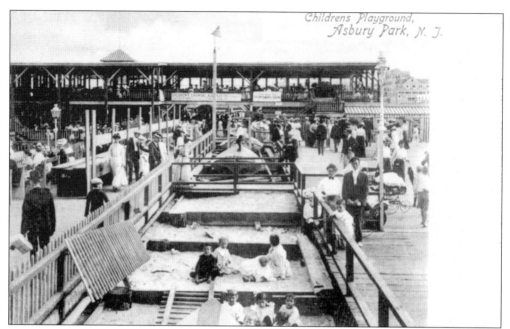

A child is on what appears to be a wooden boat in the center of this image, which depicts Ross's Pavilion and the children's playgrounds at the beginning of Asbury Park's boardwalk. The child is standing on one of the old and odd relics placed along the boardwalk by Asbury Park's founder, James Bradley. Bradley placed these items along his boardwalk to the amusement of children and to the annoyance of his political opponents.

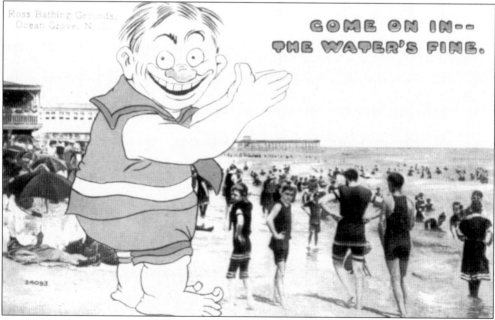

Comical cards were very popular during the early days of the postcard. Postmarked in 1909, this card was sent in the next-to-last season that Ross's operated. In 1910, the camp meeting constructed the North End Pavilion and, a year later, the North End Hotel, after which Ross's was demolished.

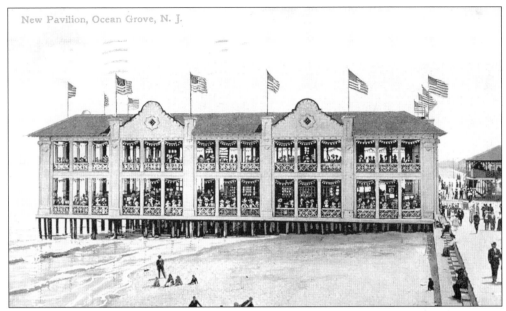

The Spanish–Luna Park style of architecture of the North End Pavilion quickly became the architectural style favored by seashore resorts. The pavilion is shown here before the hotel was finished; a portion of Ross's Pavilion was still used for the first season and is visible in the background of this card. The Camp Meeting Association dedicated the building in June 1910 and, no doubt, made the choice to construct such a lavish new structure to offer competition to bathing facilities in other resorts, especially Asbury Park.

The pavilion was the first structure completed at the North End Hotel complex, an idea that was first considered by the Camp Meeting Association as far back as 1876. The pavilion was 170 feet long and 164 feet wide, and its height was 51 feet above the boardwalk. However, the pavilion is dwarfed by the massive structure of the main hotel.

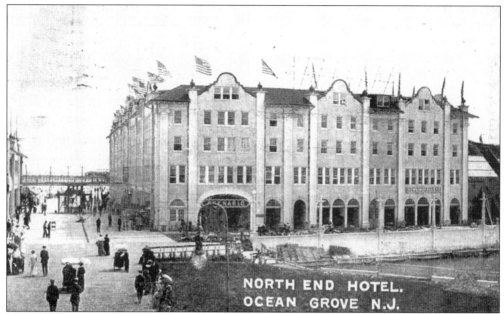

NORTH END HOTEL.
OCEAN GROVE N.J.

Postmarked in 1911, this card shows the main North End Hotel structure as originally built, identical in architecture to the pavilion. Workers on the right labor away while, in the rear, the first of two walkways connecting the hotel to the pavilion is under construction. Of note are the new concrete seawall and lampposts. This portion of the North End is still under construction in this card; scaffolding remains near the base of the wall, and the globes have yet to be placed on the cast-iron lampposts.

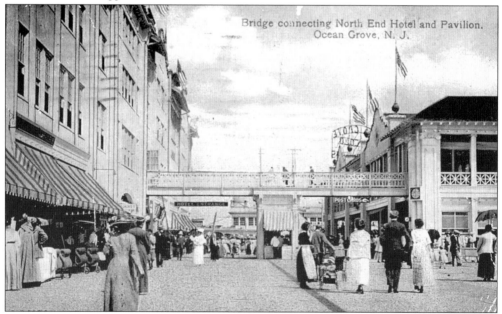

Bridge connecting North End Hotel and Pavilion.
Ocean Grove, N. J.

In this white-bordered view, the hotel has been completed and most of the attractions that would be the core of the hotel are in place. When out-of-state camp meeting trustees were in residence in Ocean Grove, it was the custom to fly their state's flag beneath the American flag on the 16-foot-tall flagpoles atop the North End Hotel.

14

According to the advertisement on the back of this card, this woman's beautiful complexion is due to her use of Misk lip color, which was sold at the White Pharmacy, in the North End Hotel.

POST-CARD

Wonderful Discovery!————Misk Lip Color

"Misk"

Brings natural color to the cheeks.

A PURE WHITE CREAM

NOT A ROUGE

MISK gives you a natural color that salt water bathing will not take away.

A pure white liquid which brings a natural red to the lips lasting about ten hours.

Get a demonstration at "THE WHITE PHARMACY"

North End Hotel Boardwalk
Ocean Grove

Preparations Guaranteed Absolutely Harmless

Printed in Saxony.

4532

Eastern Beauty Mfg. Co.
334 FIFTH AVENUE NEW YORK

This is the advertisement on the back of the adjacent card for Misk lip color.

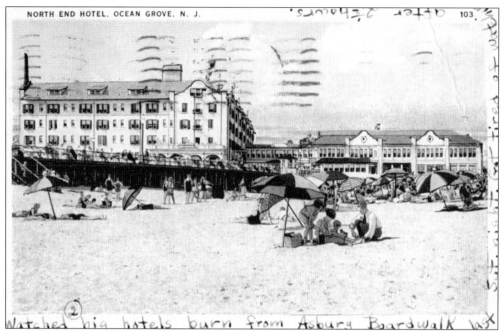

Watched big hotels burn from Asbury Boardwalk last night but got tired of watching after 2 hours.

Travelers who ran out of space on the message side of the card often found ways to include the rest of their words, as shown on this card, postmarked August 25, 1937, from Ocean Grove. In addition to watching the two hotels burn, and apparently becoming bored with the fire, the sender also wrote, "Drove to Lakehurst Hangar. Went to one dance. Wore my bathing cap and shoes all day in rain yesterday. . . . Lovingly, Frances."

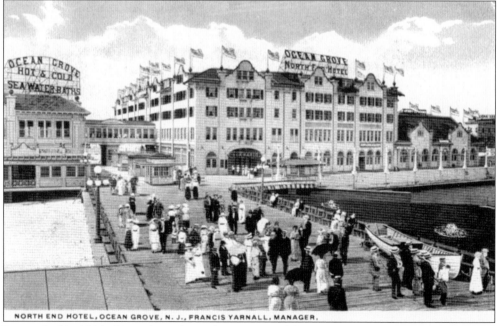

NORTH END HOTEL, OCEAN GROVE, N. J., FRANCIS YARNALL, MANAGER.

Postmarked in 1916, this card proclaims the manager of the North End Hotel as Francis Yarnall. Yarnall was the former manager of Asbury Park's Metropolitan Hotel, and according to Camp Meeting Association reports, he was well suited for the job, having grown up in the hotel industry.

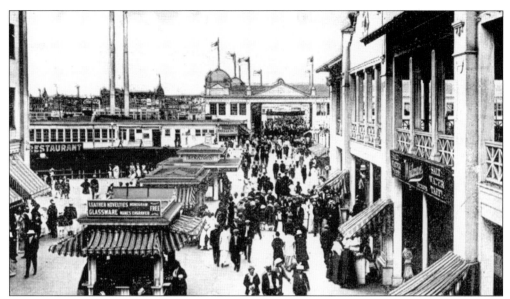

Farther north in the complex are some of the many concession stands built in the middle of the boardwalk between the hotel and pavilion. The one in the immediate foreground, selling "Leather Novelties and Glassware" with names engraved free, is one of the places at which visitors could purchase flash glass as a souvenir. This type of glassware, usually a bright red or green color, was then engraved with the words "Ocean Grove," the purchaser's name, and the year it was engraved. Today, collectors pay extremely high prices for these cups, creamers, toothpick holders, pitchers, and numerous other items marked "Ocean Grove" or "Asbury Park."

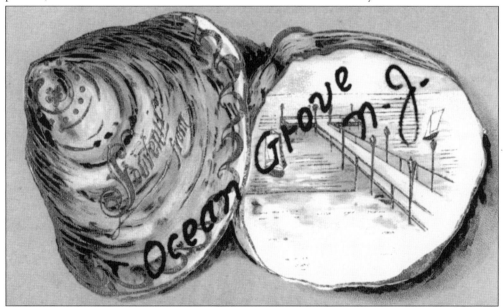

This souvenir-type postcard, likely purchased at the North End Hotel, is an embossed shell with gold glitter, printed in Germany by Union Universele in 1907. Is this an oyster shell or a clamshell? Most of the embossed cards were printed in Germany prior to World War I. On this one, which was postmarked in 1911 and sent to New York City, the vacationer wrote, "These I think are pretty, don't you? I am surprised I did not send you any cards from here."

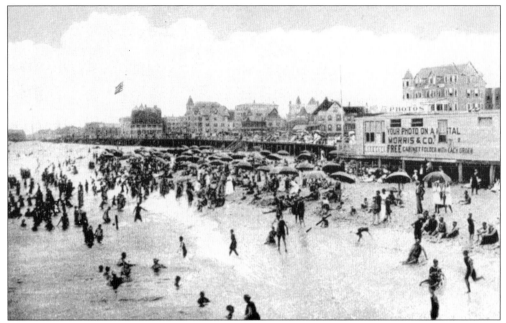

One of the original North End Pavilion concessionaires was F.S. Morris & Company, Eastman Kodak Dealers and Photographers. The company offered photograph finishing to those who had cameras; to those who did not, the company offered portrait sitting, with the end result being the customer's picture on a postcard.

This card is one of the few surviving Morris & Company postcard photographs, or as the advertising stated, "Your Photo on a Postal." What makes this card extraordinary is that the men were identified by name on a duplicate card found in the archives of the Historical Society of Ocean Grove: M. Everitt Johnson, J.W. Reading, and Elliott Everitt.

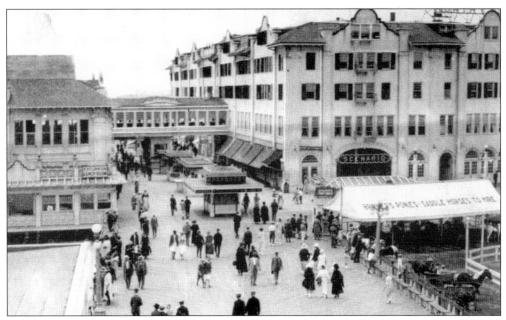

For a brief time in the 1920s and 1930s, Brower's Ponies—Saddle Horses to Hire was featured at the North End. A similar attraction was also located on Asbury Park's boardwalk, located far north of Convention Hall. The horses for both attractions were kept in stables located in West Allenhurst, about five miles northwest of Ocean Grove.

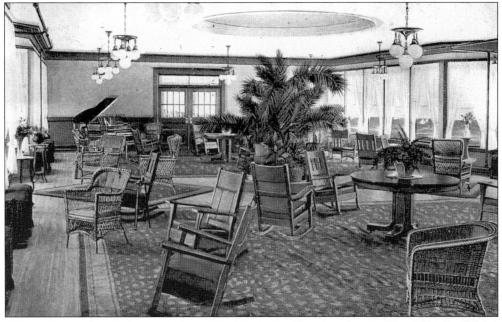

This card depicting the bridge lobby of the North End Hotel, postmarked in 1916, shows how the interior of the hotel was furnished when it first opened. The room's wicker and Mission-style oak furniture is bathed in sunlight from the windows and skylight. For nighttime, elegant Arts and Crafts–style chandeliers hang from the ceiling; one of the chandeliers is preserved in the museum of the Historical Society of Ocean Grove.

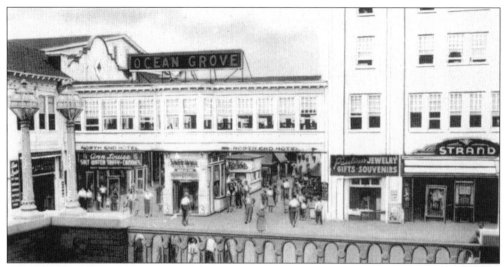

The focal point of this image is one of the two arches that carried hotel patrons across the boardwalk to the open spaces of the North End Pavilion, allowing them a panoramic view of the majestic ocean scene, not to mention the ocean breezes and cool air. The arches ran above the many concessions located along the boardwalk as part of the North End Hotel complex. Many of these concessions faded into history when the hotel was closed and then demolished; one concessionaire still thrives along boardwalks throughout New Jersey, Kohr's Frozen Custard. Known for its soft-serve ice cream and orangeade, Kohr's brought sweet magic to the Ocean Grove boardwalk shortly after World War II, following the company's start in nearby Asbury Park.

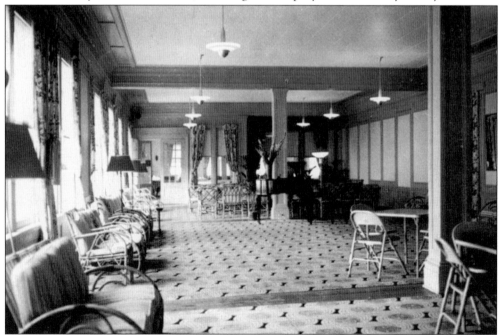

Pictured is the interior of a hotel lobby in the 1940s, with the furnishings updated for the time. The Mission-style furniture has been replaced with more Florida-theme rattan furniture. Still, the hallmarks of Ocean Grove hospitality remain, such as the piano, flower arrangements, and the bright sunlight pouring in the windows.

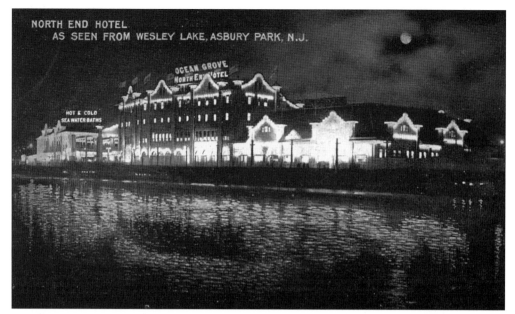

The illumination via hundreds of light bulbs at night was an important feature of the Spanish–Luna Park style of architecture featured at the North End. All of the main cornices and lines of the building were outlined. During this time period, this feature was extended to several prominent buildings in town, including the Great Auditorium. An interesting detail in this picture is the overexposure on the right, where the lights from the carousel show through the window.

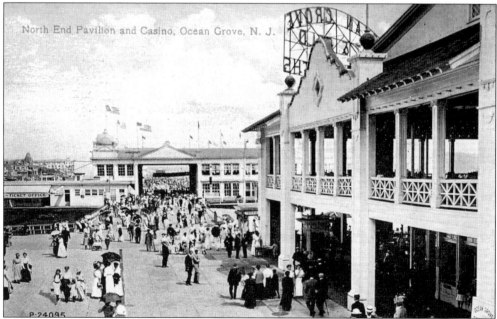

The Casino, while technically located in Asbury Park, was as much a part of the North End of Ocean Grove as attractions in Ocean Grove proper, such as the Scenario, advertised in the lower right. In fact, this seamless proximity of Ocean Grove into Asbury Park resulted in the term "twin cities." This is one of the reasons that certain Asbury Park postcards from along Wesley Lake and the boardwalk are included here.

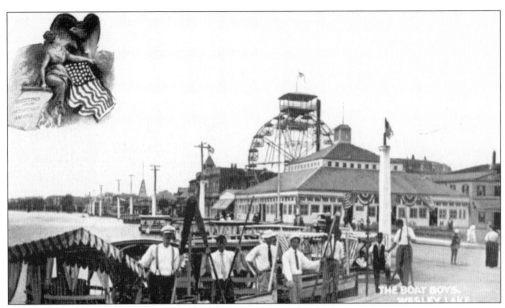

Aquatic recreation was a longstanding favorite on Wesley Lake. Pictured are the boat boys, dressed in shirt, tie, and bowler hat, waiting to take their next passenger on a scenic tour. One Camp Meeting Association report lists 56 business licenses granted for the various boat operators on Wesley Lake.

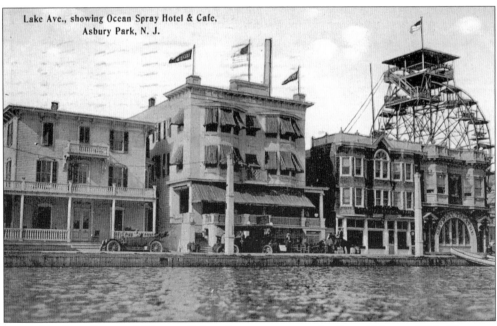

One of the first of many additions to Palace Amusements was the Crystal Maze c. 1905. The two-story brick structure, located directly west of the Ferris wheel, contained this hall of mirrors–type attraction. The second story of the building was the summer residence of Ernest Schnitzler and his family. The three structures to the left of the maze building were later purchased by Palace Amusements and demolished to build the bumper car attraction in 1956.

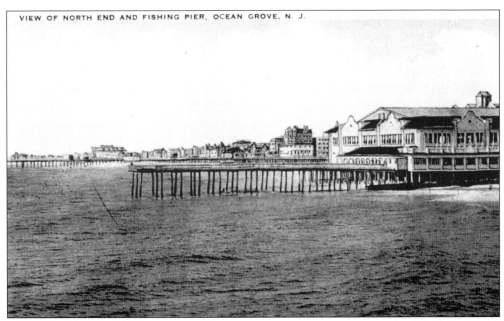

The fishing pier at the North End Pavilion was built in part for a sailing boat concession and for use as a fishing pier.

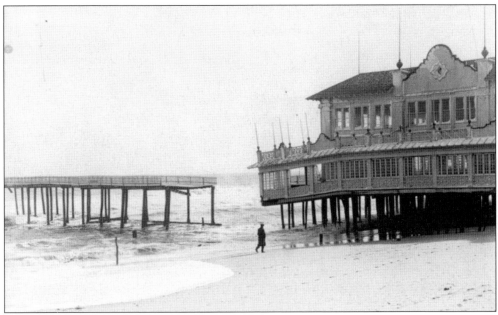

Mother Nature is a constant threat to seashore buildings, as seen in this card showing the fishing pier that was a part of the North End Pavilion. After being rebuilt several times, the pier was finally demolished during a winter storm in 1938. Here, a lone person walks along the snow-covered beach, surveying the damage to pier and pavilion.

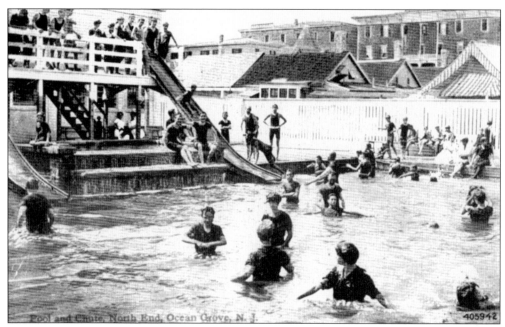

For visitors not content to deal with the surf, tides, and undercurrents of the Atlantic Ocean, the Camp Meeting Association added a swimming pool as part of their North End improvements. When first opened, the pool featured two water slides. Judging by the long lines behind them, the slides appear to have been a popular feature.

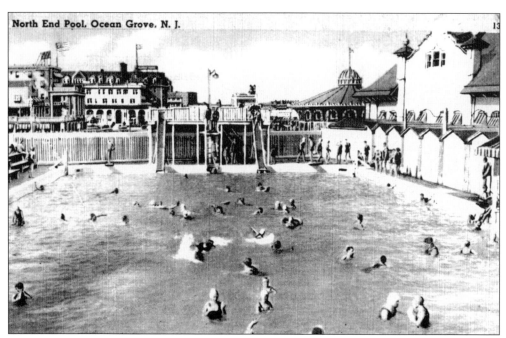

A later view of the swimming pool shows the Asbury Casino, Plaza Hotel, and merry-go-round building in the background. The bathhouses to the right were rented for $10 a week to the pool's patrons.

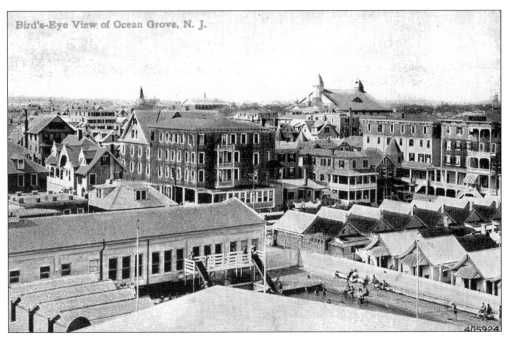

This aerial view of the swimming pool was taken from the North End Hotel. Visible are landmarks such as the Marlborough Hotel and tents. Also of note are the bathhouses and offices to the left and behind the water slides.

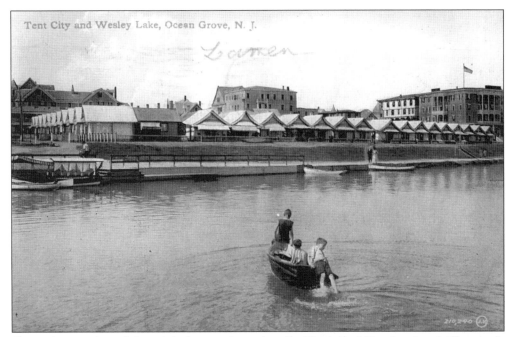

Shown is a portion of the original tent colony that the North End Hotel replaced. The gentle slope of the grass in front of the tents was replaced with a concrete seawall with cast-iron lampposts all along the promenade.

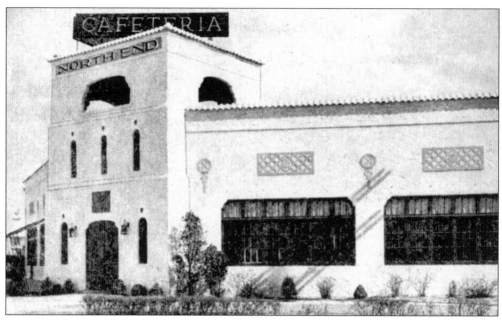

One of Ocean Grove's most legendary cafeterias was the North End Cafeteria, with its Spanish stucco exterior and interior. The smells of delicious home cooking were enjoyed in the cafeteria's cozy surroundings, which included numerous sconces on the walls for lighting, as well as faux cobblestone flooring. Some claim the roasted round of beef and the mashed potatoes were the best in Ocean Grove and Asbury Park.

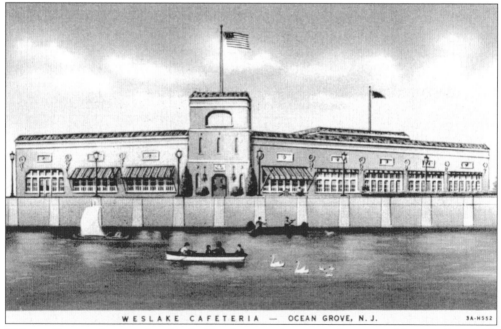

WESLAKE CAFETERIA — OCEAN GROVE, N. J. 3A-H552

This rare linen card was made with deckle edges, an uncommon feature on this type of postcard. Such cards are hard to find with their corners still sharp after 50 or so years of handling. This one depicts the North End Cafeteria operating under the name Weslake Cafeteria, with a capacity for 600 people. The building currently serves as a storage garage for the Camp Meeting Association.

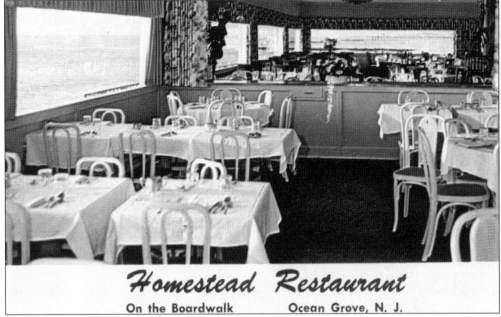

Homestead Restaurant

On the Boardwalk Ocean Grove, N. J.

This interior view of the Homestead Restaurant dates from *c.* 1950. The Atlantic Ocean is visible through the windows. Mirrors above the wainscoting add the illusion of the dining space being much larger. As was the tradition, only full meals were served on Sunday. Visitors fondly remember waiters coming to the table with hot corn bread and serving it with silver tongs. The Homestead was also famous for its fruit cup topped with homemade orange ice and melon ball with a sprig of mint.

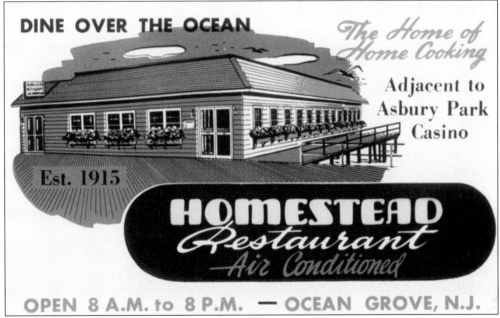

DINE OVER THE OCEAN

The Home of Home Cooking

Adjacent to Asbury Park Casino

Est. 1915

HOMESTEAD *Restaurant* *Air Conditioned*

OPEN 8 A.M. to 8 P.M. — OCEAN GROVE, N.J.

This stylized view of the Homestead Restaurant, founded in 1915, was taken shortly after the complex opened. The back of the card reads, "Specializing in affairs for groups. Special Menu for Children. Makes Family Dining a Pleasure."

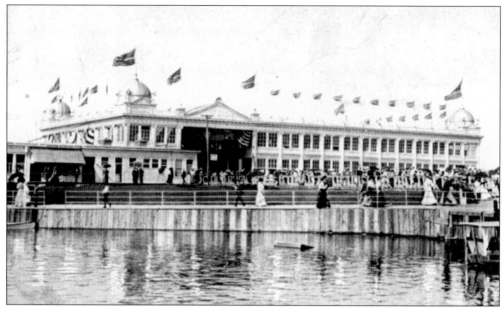

Asbury Park's original Casino—at the time one giant wonderland of sights, smells, and sounds—ushered visitors seamlessly into Asbury Park from the Ocean Grove boardwalk.

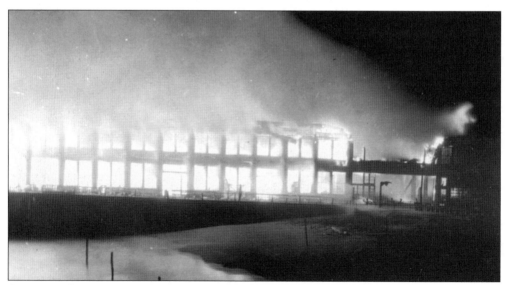

A great conflagration in January 1928 destroyed the Casino, as seen in this exceptional postcard. The Casino's adjoining facilities were also destroyed. Fortunately, the fire did not spread beyond the Casino or into Ocean Grove's North End.

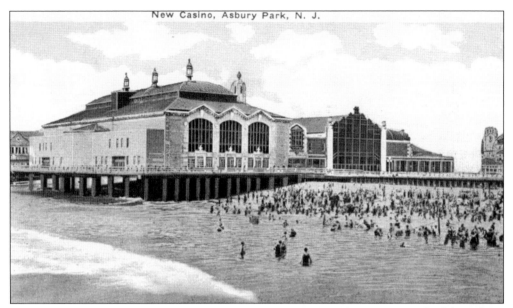

As they had already commenced work on Convention Hall, at the opposite end of the Asbury boardwalk, the city chose the firm of Warren and Whetmore to design the new Casino building, shown here. The firm was based out of New York City and had also designed New York City's Grand Central Terminal building. The Casino complex originally included an arena, arcades, shops, restaurants, and a carousel.

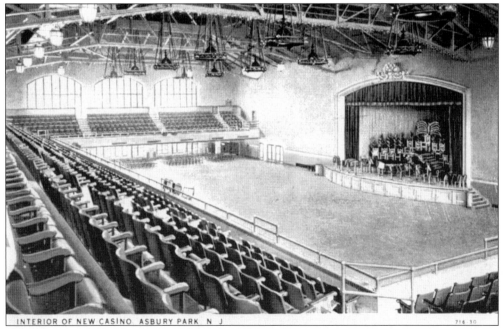

INTERIOR OF NEW CASINO ASBURY PARK N J

This rare view shows the interior of the Casino's area, prior to its conversion into an ice-skating rink. The stage is set up for an orchestra concert, a popular event in World War II–era Asbury Park. The floor has been cleared of seats so that servicemen could dance the night away with their sweetheart, away from home.

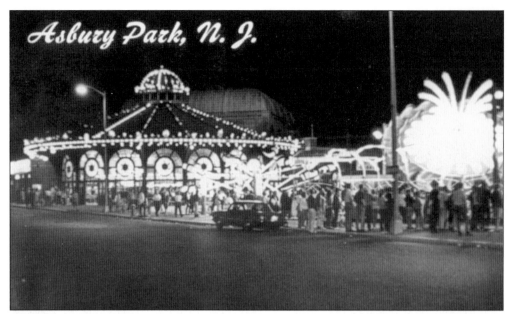

The Casino's function as an amusement area increased during the 1950s and 1960s, when other attractions such as the bumper cars, fun house, and haunted house ride, were added to the Casino. This night view shows the elements of the Luna Park style, with the inclusion of hundreds of light bulbs outlining portions of the building. Visitors often described the Casino as "a glowing jewel" at night.

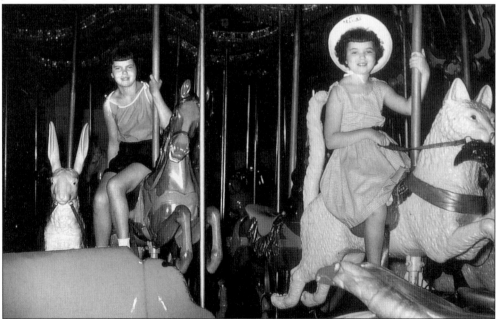

The Casino carousel was manufactured in 1932 by the Philadelphia Toboggan Company. Unlike the Palace carousel or the Ocean Grove merry-go-round, the Casino's did not feature a menagerie of different animals. When the Casino Amusement Park closed in 1990, the last of the Wesley Lake carousels was sold to the Family Kingdom Amusement Park in Myrtle Beach, South Carolina. Pictured are Vivian (left) and Linda Schunk enjoying the Ocean Grove merry-go-round.

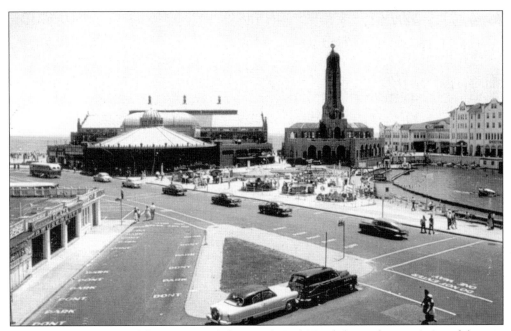

This general overview of the Casino and the North End Hotel shows the proximity of the two facilities. There is little doubt many Ocean Grovers were lured to the Casino, away from their town on Sundays, when all the Ocean Grove North End attractions were closed.

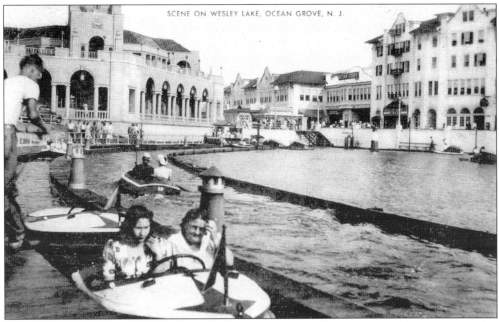

Gas-powered motorboats were among the first modern amusement attractions added to Wesley Lake. The boats followed a channel way constructed in the lake, complete with miniature lighthouses. The boats were used to advertise various Asbury Park and Ocean Grove businesses, with a plaque for the business located on the bow of the boat.

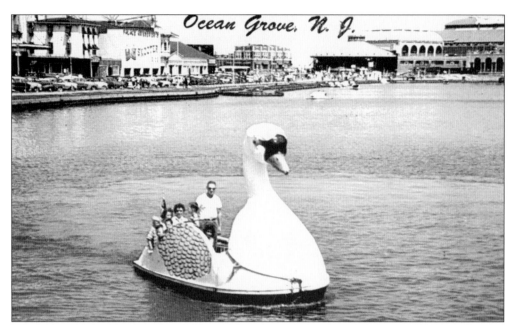

Perhaps the most loved attraction in Wesley Lake was the swan boat, shown here in the late 1950s. Swan boats were popular attractions in amusement centers from the 1930s. Many were manufactured by the Lusse Brothers of Philadelphia, who also manufactured the bumper cars in the Palace Amusements. A ride around the lake cost the passenger 10¢.

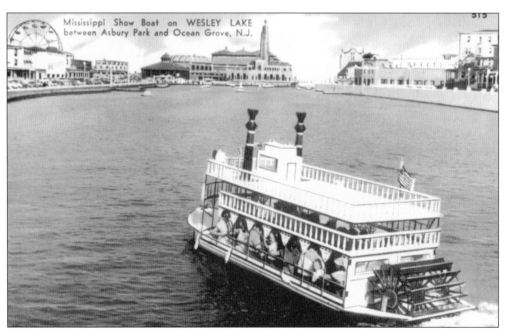

In the late 1960s, a Mississippi River–style paddleboat was added to Wesley Lake, in addition to the swan boat, motorboats, and U-Pedal boats. All of these attractions were operated under the auspices of the Central Amusement Corporation.

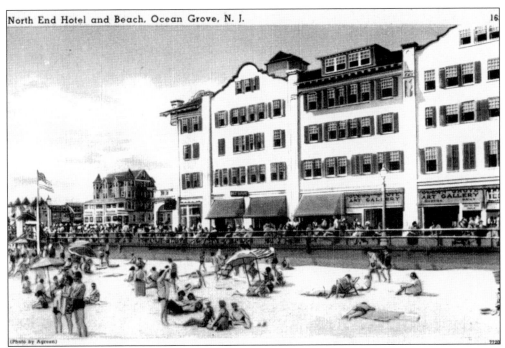

This view shows the eastern facade of the main hotel building, with various stores on the ground floor. One business was an auction house, in which auctions were held nightly from 8:00 until 11:00. These auctions featured all sorts of antiques and other items at bargain-to-expensive prices.

Due to regulations and customs set forth by the Camp Meeting Association, no persons wearing bathing suits were permitted on the boardwalk proper. A system of tunnels was built, both for hotel maintenance and for the purpose of accessing the beach. The concrete stairs at the left near the boardwalk were the main access for the tunnel that led to the bathhouse lockers.

As Asbury Park was a segregated resort in the early part of the 20th century, African American residents and visitors were not allowed to bathe on the city's beaches between the Casino and Convention Hall. African Americans had to use the so-called "black beach" located between the Casino and North End Pavilion. Interestingly, Bradley, a devout Christian, initially resisted segregating Asbury Park's beaches but finally did so reluctantly.

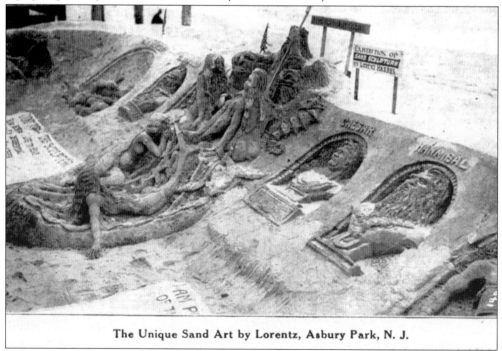

The Unique Sand Art by Lorentz, Asbury Park, N. J.

This card shows the work of talented sand sculptor Lorenz Harris, father of the late Dr. Lorenzo Harris, a prominent and much loved Asbury Park physician. Postcards depicting African American history are rare and vigorously sought by collectors.

Farther north on the Asbury Park boardwalk was Oceanic Park, also known as Bob Fountain's Bubbleland. This park featured numerous kiddie rides over the years, and the favorite, the train ride, was called the Bubbleland Express. The Bubbleland title was used because, in the center of the park, there was a giant bubble-making machine that produced copious amounts of bubbles, much to the delight of small children. It is probable that someone in the employment of the park was a fan of the Lawrence Welk television show.

Miniature Golf Course, showing Berkeley Carteret Hotel, Asbury Park, N. J.

Since commercial ventures were confined to the north and south ends of Ocean Grove, there was no place for activities like miniature golf. Visitors again had to seek this entertainment by taking a short walk up the Asbury Park boardwalk. This miniature golf course was located at the foot of Third Avenue.

When both resorts were at their prime, there were four movie theaters located along the shores of Wesley Lake: the Strand in Ocean Grove, the St. James, the Lyric, and the grandest of them all, shown here, the Mayfair. No doubt this was another favorite spot for Ocean Grove people on Sunday, when the Strand Theater was closed. The Mayfair was a Moorish-style building and featured a lighting effect on the interior that simulated day turning into night, played before the start of each feature. Sadly, this structure was demolished for a condominium development that never materialized.

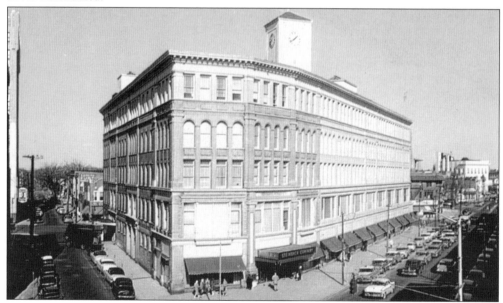

For more than 110 years, the Steinbach Department Store sold its goods from downtown Asbury Park. On a clear day, the clock tower atop the building was visible for 17 miles out to sea. In addition to retail sales, Steinbach's did a brisk business supplying the many hotels and related establishments in Ocean Grove and Asbury Park.

Two

THE BOARDWALK, BEACH, AND SOUTH END

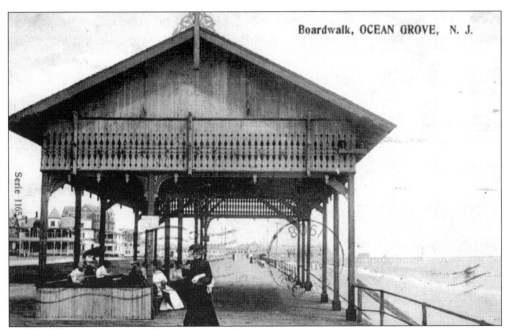

Entitled "Boardwalk," this card was made in Germany and published by the Union News Company of New York City. It is one of the most detailed of the beach pavilion. An electric line of knob and tube wiring is visible halfway up the wooden gingerbread decoration. Mailed on August 9, 1908, to Trenton, this card features 12 small pullout scenes of Ocean Grove in black and white.

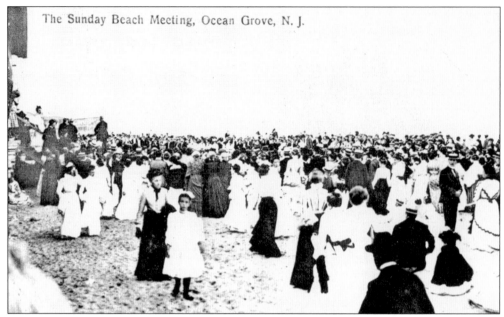

The Sunday Beach Meeting, Ocean Grove, N. J.

At this rare Sunday beach meeting, the crowd numbers between 300 and 400. One has to wonder how well the group could hear the preacher over the sound of the breaking waves. Made in Germany and published by the H. Hagemeister Company of New York, the card was mailed on August 30, 1907, to Wanaque.

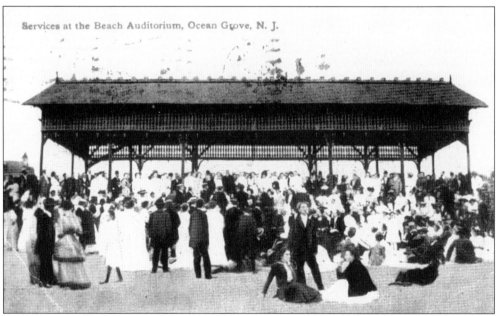

Services at the Beach Auditorium, Ocean Grove, N. J.

This pavilion was erected in 1878 at the foot of Ocean Pathway to replace a small and poorly constructed one that had been demolished by a winter storm. This new pavilion was described as large, substantial, and in every way, a more tasteful structure. The pavilion had a curly finial (page 37) and block cresting on the peak of the shingled roof. The cost of building was $500, which did not include painting.

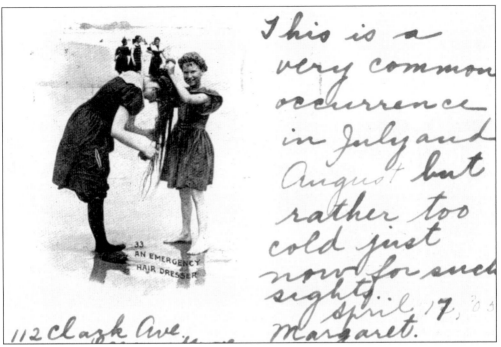

This young woman was likely knocked over by a large wave, which ruined her hair style. Later, the wearing of bathing caps avoided such problems and was a requirement for women bathers for many years.

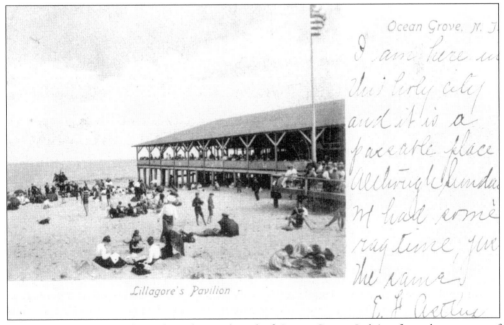

Lillagore's Pavilion was located on the south end of Ocean Grove. Judging from the message of having "rag-time" on Sunday, the authors must have ventured into Asbury Park or Bradley Beach.

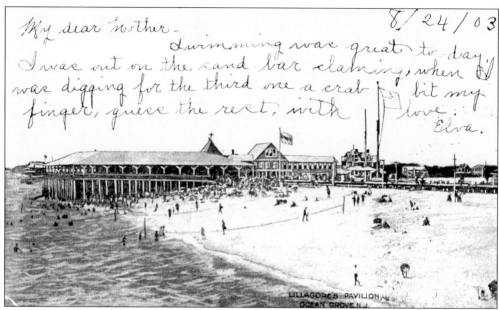

My dear mother—
Swimming was great to day, I was out on the sand bar clamming, when I was digging for the third one a crab bit my finger, guess the rest, with love. Elva.

8/24/03

This general overview shows Lillagore's Pavilion, with the Kent Homestead of Bradley Beach visible in the rear. The date 8/24/03 is, of course, August 24, 1903; many postcards have reached or are approaching their centennial year and, like this card, are in remarkable condition for their age.

South End Bathing Grounds, Ocean Grove, New Jersey. Published by F. R. Price.

In the spring of 1915, a great fire destroyed the South End Pavilion. An alternative plan was developed to temporarily provide bathing facilities for the South End residents and visitors. Called the South End Bathing Camp, it consisted of a block of small, snow-white changing tents securely fastened to wooden platforms on the beach. The other side of the boardwalk had numerous, attractive sales booths that carried items such as Ocean Grove novelties, photographic supplies, and refreshments.

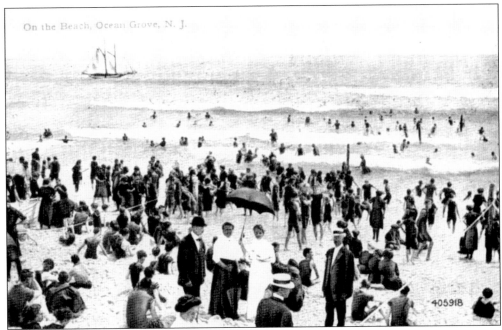

On the Beach, Ocean Grove, N. J.

The message on this card, sent to Albany, New York, says, "Dear Peggy, I received your card. We are all enjoying ourselves immensely. All I do is sit on the porch and visit with everybody and eat. The meals are the best I ever had. Love to all, Aunt Melissa."

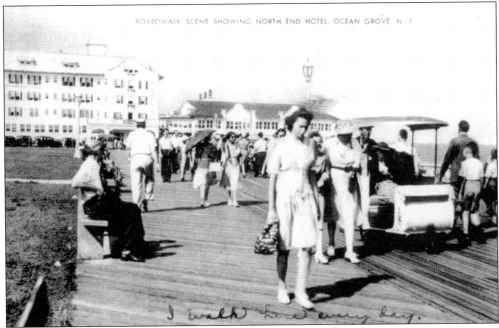

BOARDWALK SCENE SHOWING NORTH END HOTEL, OCEAN GROVE, N. J.

This real-photo postcard shows one of the rolling chairs that ventured down the Ocean Grove boardwalk. The Camp Meeting Association, which maintains the boardwalk, provided a special lane on the boardwalk to control the traffic flow of the rolling carts. As was the custom, the chairs did not operate on Sundays.

This is a view of the South End Bathing Beach. The building with three turrets is the Lillagore Hotel, one of Ocean Grove's oldest continuously operating hotels. The umbrella concession was operated by the Ocean Grove Camp Meeting Association.

The line of canopies on the South End Pavilion provided some protection from the sun and heat for the various candies and confectioneries on display in the glass store windows. One hurricane in the 1960s lifted and pushed the entire boardwalk along with a lot of sand into the street where the jitney bus is pictured.

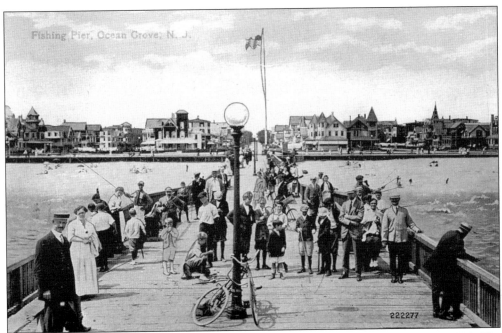

The Ocean Grove Fishing Pier was originally placed at the foot of Embury Avenue in 1891. The Ocean Grove Fishing Club was established soon after in a clubhouse at the end of the pier.

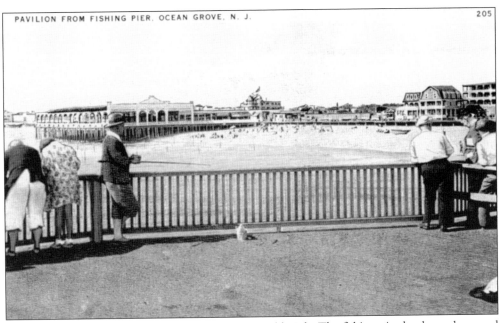

PAVILION FROM FISHING PIER, OCEAN GROVE, N. J. 205

This view of the pier looks south over the ocean and beach. The fishing pier has been destroyed a number of times due to storms, most recently during the December 11, 1992, northeaster. The pier was rebuilt and recently lengthened to permit fishing after the beach was widened.

Despite this woman's heavy woolen bathing suit, as was the custom of this time period (*c.* 1911), this image was considered risqué. The sender of the card notes to her good friend that she is still "looking" for her, presumably for a prospective mate.

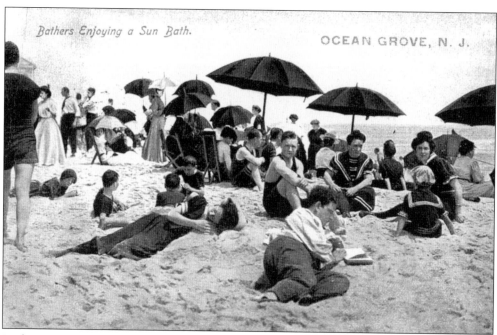

Bathers Enjoying a Sun Bath.

OCEAN GROVE, N. J.

In this ageless image, a man reads his book while a woman sleeps in the warm sun, with cool sand beneath her. For everything that has changed in Ocean Grove, nothing has really changed; even today, on a warm summer afternoon, this scene is duplicated—with some variation in bathing attire.

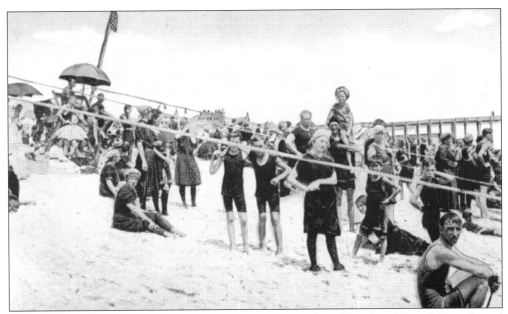

This view looks north toward the fishing pier from the South End beach, with the lifeguard stand visible. It was a longstanding tradition in Ocean Grove that women wearing a sundress or skirt could wade up to their knees without having to pay the fee assessed for ocean bathing.

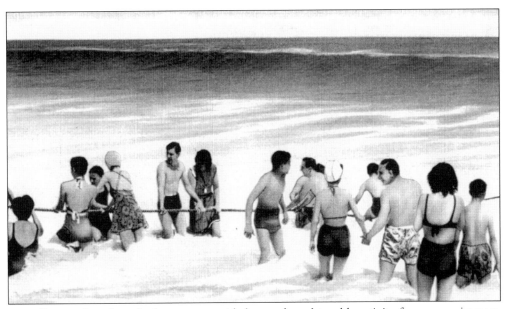

Rope lines anchored out in the ocean provided a rough-and-tumble activity for many swimmers. Bathers held on to a one-inch-thick rope as breaking waves tried to carry them ashore. A sound night's sleep on a firm horsehair mattress rejuvenated tired muscles so that, come morning, the body could answer the surf's challenge again.

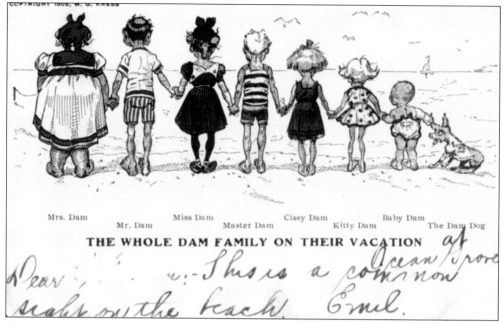

COPYRIGHT 1905, W. G. KRESS

Mrs. Dam Miss Dam Cissy Dam Baby Dam
 Mr. Dam Master Dam Kitty Dam The Dam Dog

THE WHOLE DAM FAMILY ON THEIR VACATION

This postcard, entitled "The Whole Dam Family on their Vacation," was mailed from Ocean Grove on September 4, 1905, at 12:30 p.m. It arrived at Box 163 in Wilmington, North Caroline, on September 8 at 6:00 p.m. Its message reads, "Dear ——, This is a common Ocean Grove sight on the beach."

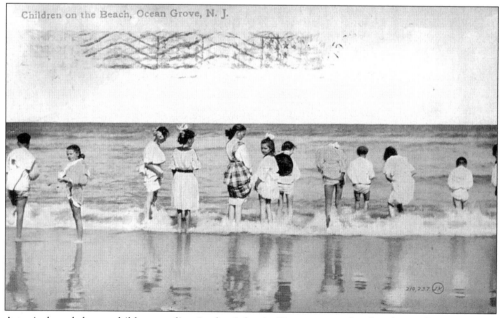

Children on the Beach, Ocean Grove, N. J.

A typical card shows children wading in the Atlantic Ocean on a calm day during low tide. The person who sent this card to Hackensack in 1910 wrote, "Mamma, Elva and I have had a lovely time here this week. I go in bathing every day. Love to all, Bertha."

46

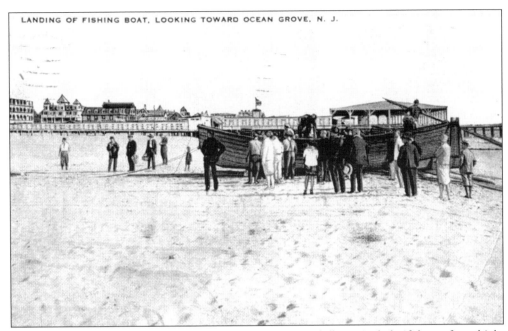

The launching of a boat from the beach required a certain skill, particularly if the surf was high. The boat on its return would be pulled ashore on wooden rollers laid on a plank track. Horses and block and tackle would be used depending on the size of the boat and the tonnage of the catch.

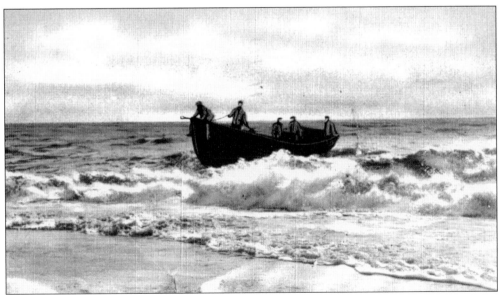

What a thrilling sight it must have been to see a fishing boat cresting a wave, especially to city residents on vacation. This card was sent to City Island, New York: "Dear Adeline, I am enjoying stay. We had a beautiful Christmas in August service this morning. Then I read my papers on the boardwalk. Last night my friends from Tremont Church and I met and sat on beautiful boardwalk. Love Margaret." The Tremont Church was located in the Bronx.

There is an eternal, mystical force that draws people back to the shore once they have been introduced by gentle hands to the sand and surf.

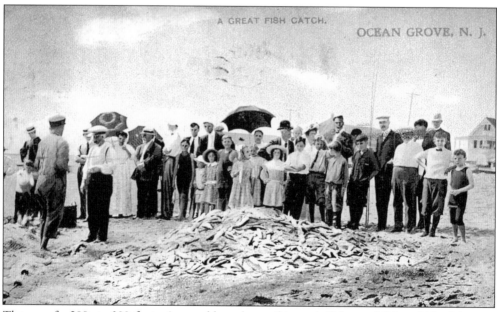

The use of a 200- to 300-foot seine could produce a fair catch if the weakfish and bluefish were close to the shore. The price of fish varied by the pound and the heat of the day. All fish were guaranteed to be fresh.

The girl pictured in *Ocean Grove Girl,* by artist H. King, wears a blue bathing suit with yellow trim. This much sought-after postcard is one of a series showing bathing beauties in the clothing styles of Charles Dana Gibson. Other cards feature girls of Keansburg, Long Branch, Asbury Park, and Atlantic City. The series was originally printed on silk patches as a premium in a cigarette pack, much to the disapproval of the Camp Meeting Association because of its stand against tobacco and spirits.

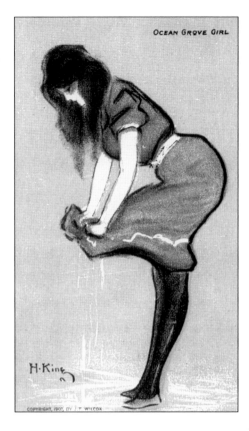

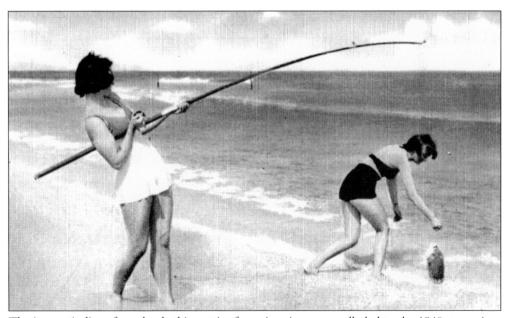

The impracticality of woolen bathing attire for swimming eventually led to the 1940s two-piece bare-midriff styles to the 1990s thong. One wonders what bathers will be wearing in the year 2020.

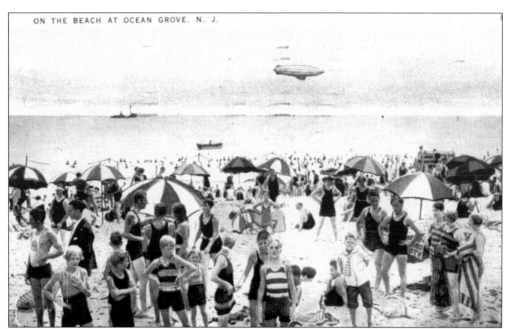

This card has all the sights of the Jersey Shore: the blimp, the fishing and lifeguard boats, the bathing ropes, the lifeguard stand, the umbrellas, and people having fun.

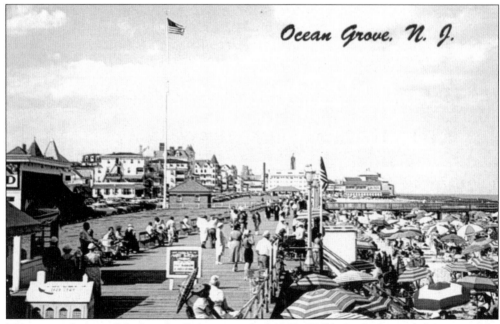

This postcard view of the boardwalk is postmarked 1962. Visible in the lower left is one of the many donation boxes placed around town to raise funds for Ocean Grove's centennial celebration in 1969. The flagpole at the base of the fishing pier also doubled as an exhaust stack for Ocean Grove's sanitary sewer system.

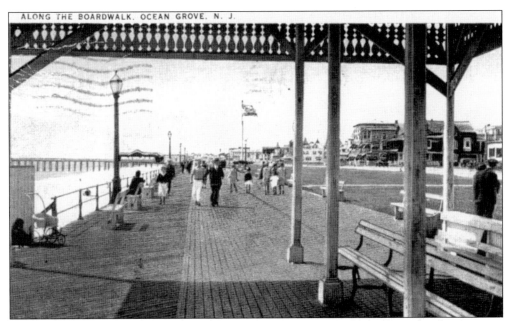

Looking south, this view shows the boardwalk from the interior of the beach pavilion. The Victorian-style structure was destroyed in one of the coastal storms (1944) and has been replaced with the present one, as shown below.

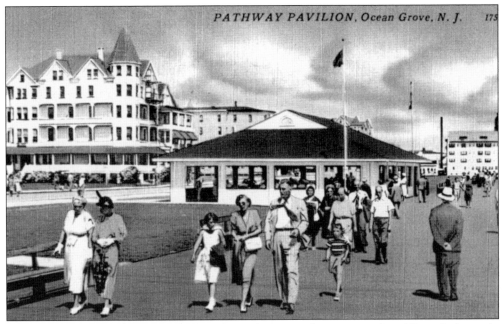

PATHWAY PAVILION, Ocean Grove, N. J. 175

The current Ocean Pathway Pavilion, the site of many performances and weddings, is shown in this linen-era postcard. The pavilion was recently dedicated to honor Harry Eichorn, who has directed the Ocean Grove Summer Band for more than 50 years. Band concerts are held weekly in the summer months, with crowds so large that the audience spills out onto the boardwalk.

Known for its benches, Ocean Grove has some of the best people-watching opportunities available in New Jersey. The benches near the boardwalk railing, as seen in this vista of the North End Hotel, were the most unique. A hinge mechanism allowed the person sitting on the bench to adjust it to face toward the ocean, gazing at the surf and sand, or toward the town, looking at the lovely Victorian architecture and the people strolling the boardwalk.

After being damaged by storms, the boardwalk was moved west toward Ocean Avenue, north of the Ocean Pathway Pavilion, just before the North End Pavilion. This card shows the stone bulkhead installed to minimize a storm's impact on the pavilion and boardwalk.

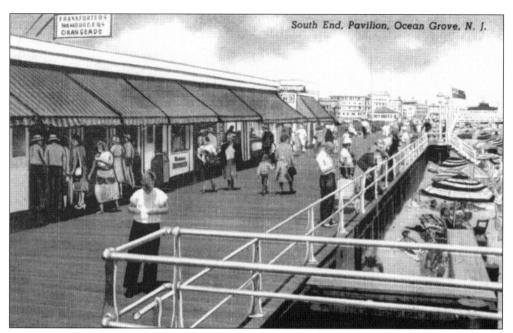

This view shows the South End concessions and the entrance to the bathhouse tunnel, visible at the lower right behind the boardwalk railing. This tunnel and the one at the north end allowed people to observe the regulation of not wearing bathing attire on the boardwalk.

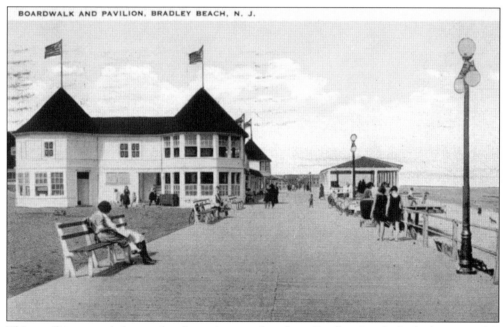

This pavilion served the needs of vacationers who chose Bradley Beach for bathing—as did, perhaps, many Ocean Grove residents on Sunday, when Ocean Grove's beaches were closed in observance of the Sabbath.

A Scottish terrier has been superimposed on this image of the beach. Other similar collectable images include an Irish setter, two different Scottish terriers, a German shepherd, and a scruffy-looking hound. Cats do not seem to go to the beach; apparently they dislike getting sand in their fur.

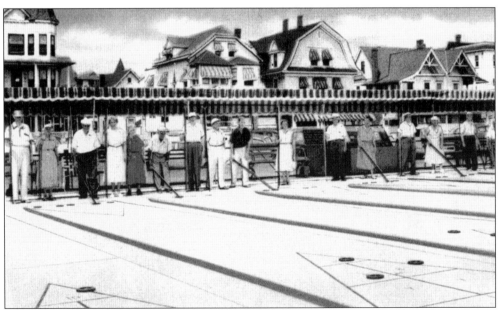

These shuffleboard courts are located at the corner of Broadway and Central Avenue. Other outdoor amenities include a tennis court, a bocce court, and a children's playground. Parking is at a premium in the summer. One day, Emma approached the shuffleboard gang and asked them to help her find her car. The game was stopped and everyone went to look for Emma's car, but after a half-hour of searching, no car had been found. John, who was walking by, remarked, "Emma, you sold the car two years ago." The game then resumed.

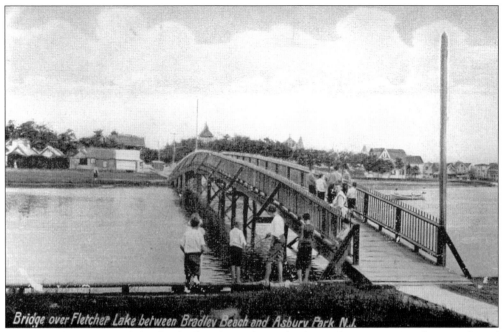

This card shows one of the footbridges located on Fletcher Lake, joining Bradley Beach and Ocean Grove. When Ocean Grove was founded, this lake was known as Duck Pond. However, the Camp Meeting Association changed the name to Fletcher Lake to better reflect the town's Methodist heritage.

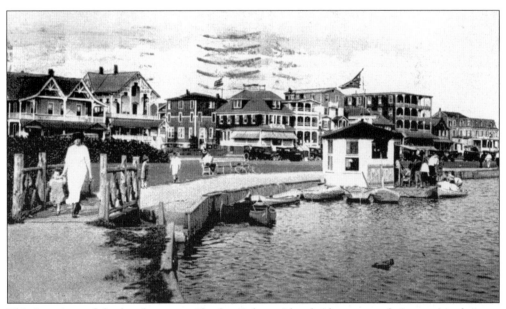

This is a view of the boathouse on Fletcher Lake, with a bridge over a drainage pipe that was part of the surface water system that emptied into Fletcher Lake. The area is one of the low spots in Ocean Grove, and at one time a lake called Carvosso Lake was located near the intersection of Broadway and Central Avenue.

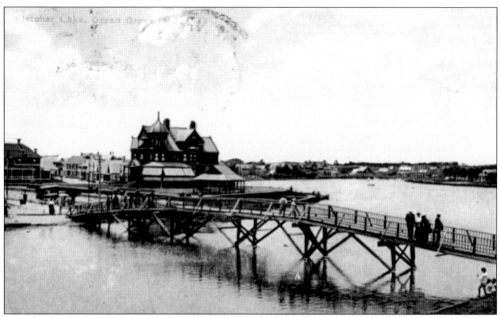

Originally the Kent Homestead, this large structure (on the Bradley Beach side of Fletcher Lake) became the Lakensea Hotel *c.* 1900. The Kents were members of the Ocean Grove Camp Meeting Association. Apartments currently occupy the site.

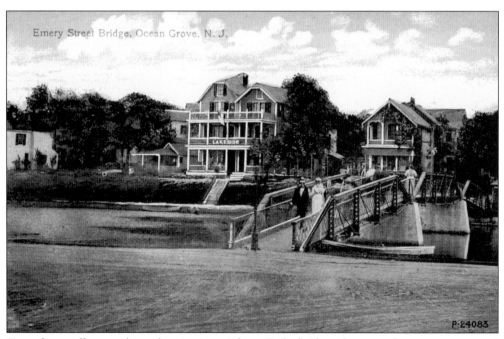

Since foot traffic was always heavier into Asbury Park, bridges that were larger, stronger, and more elaborate bridges were in order. Today, concrete bridges serve those traveling across Wesley Lake, but a wooden bridge is still in place on Fletcher Lake.

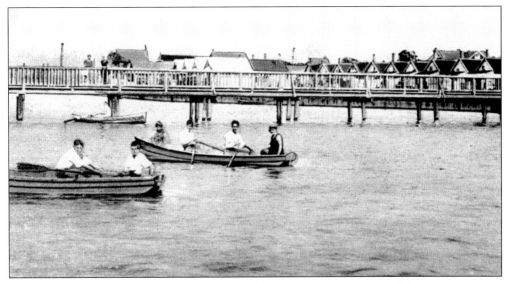

These tents were located along the shores of Fletcher Lake on the site of the present Francis Asbury Manor. Rowing has been a pastime on Fletcher Lake since the early days of the Camp Meeting Association. In the 1960s, one enterprising young man who lived along the lake discovered he could make money by renting out his family's rowboat to tourists eager to enjoy the natural beauty of the lake.

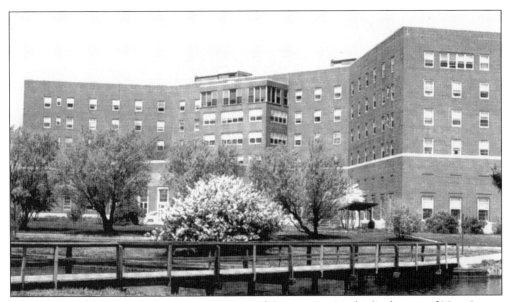

Opened in 1947, Francis Asbury Manor is one of the premier Methodist homes of New Jersey. The rooftop now features well-concealed cellular phone transmission towers, providing better cellular communication along the shore. It is also Ocean Grove's only high-rise building.

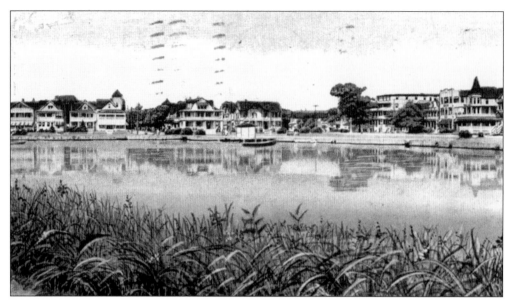

This view shows Fletcher Lake from the southeast. This is one of the few cards that have the natural lakeside vegetation in the foreground. It was mailed to Newtown in Bucks County, Pennsylvania, in 1936, from the Osborne House. Its message reads, "Dear Maud, I am taking my usual summer outing. We are having fine cool weather which we are all enjoying. Also plenty of meetings of all kinds. Love, Sue B."

The Seashells by the Seashore card series featured different scenes of Ocean Grove and other shore towns. It was quite simple to change the town's name from Atlantic City to Ocean Grove. These cards are fine examples of the engraver's artistic skill.

Three
A LOOK AROUND

Arthur Livingston, who published this Ocean Grove card, is credited with conceptualizing the "Greetings from" series of postcards. The style of card was duplicated many times over, so much so that some 150 distinct "Greetings from Ocean Grove" cards exist.

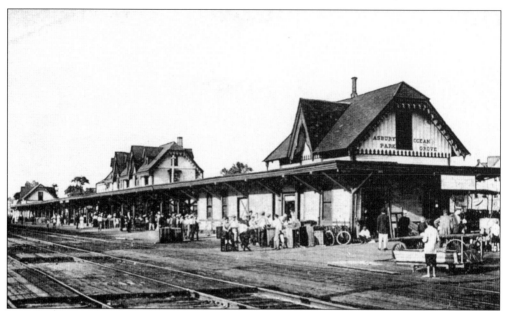

The New York and Long Branch Railroad, a joint venture between the Pennsylvania Railroad and Central Railroad of New Jersey, came to Ocean Grove and Asbury Park in 1875. The expansion of the railroad is credited for the area's enormous growth during this time period. One account lists 136 separate trains as having Ocean Grove as their destination on a busy July day.

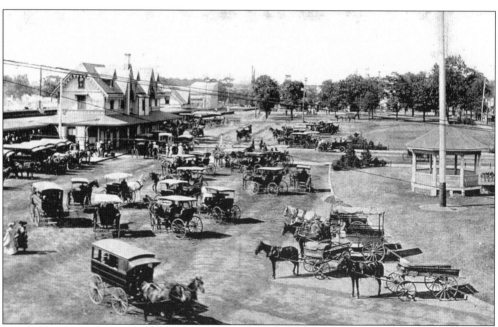

The many horse-drawn buggies waiting for passengers would likely have taken the person who penned this message on June 28, 1912, to her job on Lake Avenue in Ocean Grove, as she writes of her responsibility: "I am back to Ocean Grove again. I am night nurse for an invalid. . . . I have home privileges and comfort. I go out every day and take real long walks sometimes. . . . Lovingly Bertha Krayhill."

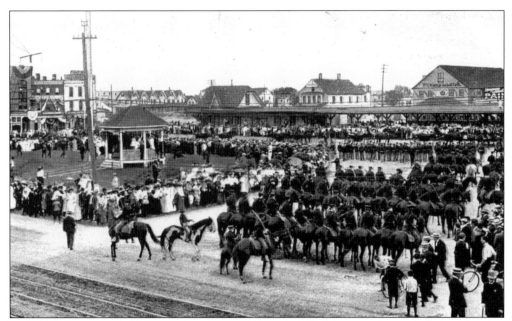

Long before limousines and car service, even the governor of New Jersey came to Ocean Grove and Asbury Park by train. In this early view of the train station, everyone seems to be anxiously awaiting the governor's arrival, including mounted National Guard troops.

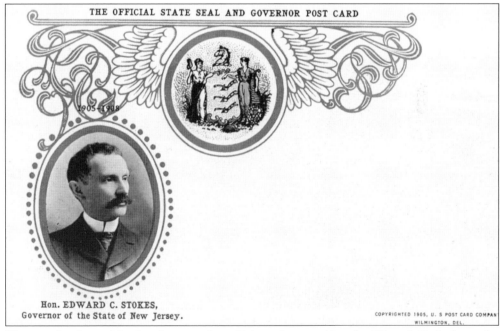

THE OFFICIAL STATE SEAL AND GOVERNOR POST CARD

1905-1908

Hon. EDWARD C. STOKES,
Governor of the State of New Jersey.

COPYRIGHTED 1905, U. S POST CARD COMPANY
WILMINGTON, DEL.

The people pictured in the above card could have been waiting for Edward C. Stokes, who served as governor of New Jersey from 1905 through 1908. Stokes, a distant relative of Ellwood H. Stokes, the Camp Meeting Association's first president, was also elected as a Camp Meeting Association trustee in 1906.

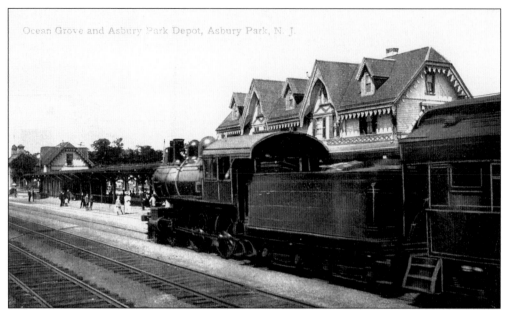

Shown in this Valentine and Sons postcard of the Ocean Grove and Asbury Park Depot is one of the steam engines that serviced this station in the early days of the resorts. The locomotive is an American-type 4-4-0, meaning it has four wheels in front, four wheels driving the locomotive, and no wheels in the back. This locomotive appears to be one of the Pennsylvania Railroad's Class D-16sb American types, which were frequently used in branch-commuter line service. An example of this type of locomotive is preserved at the Railroad Museum of Pennsylvania in Strasburg, Pennsylvania.

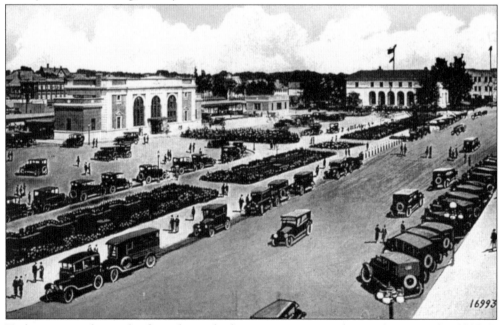

To better serve the needs of travelers to both resorts, a more modern station opened *c.* 1925. It is thought that this station building was the inspiration for a popular toy train station model produced by the Lionel Corporation. Sadly, this station was demolished in the early 1980s.

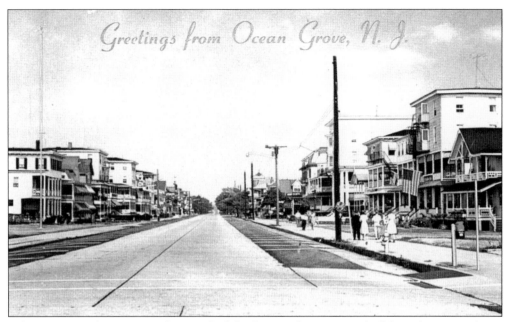

Taken on a Sunday, prior to the repeal of the "No Parking on Sunday" law, this image shows another important aspect in the development of vehicular traffic reaching Ocean Grove. On the telephone pole toward the right is a sign for the Garden State Parkway, which opened in 1955 and made traveling to the area via car a much easier task.

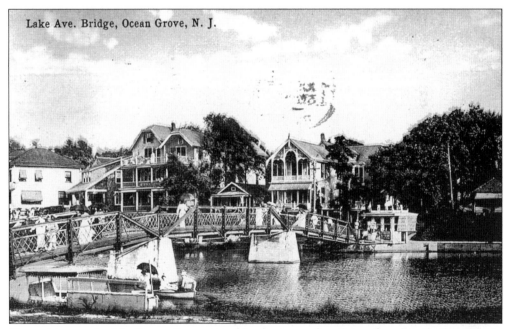

Once visitors arrived in Ocean Grove, travel by foot was often the preferred method, as seen in this card depicting one of the Wesley Lake footbridges. Postmarked in July 1917, this card says a great deal about the level of relaxation obtained from visiting Ocean Grove, "This beats work all out – what say you? . . ."

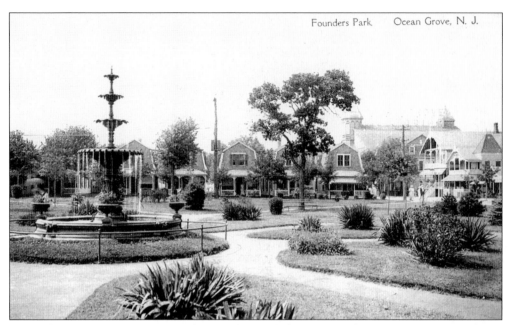

Originally known as Thompson Park, Founders Park featured this fountain and a memorial vase for Ocean Grove's founding fathers, which was the reason the park's name was changed. Now used as a planter, the fountain is targeted to be restored if sufficient funds can be raised.

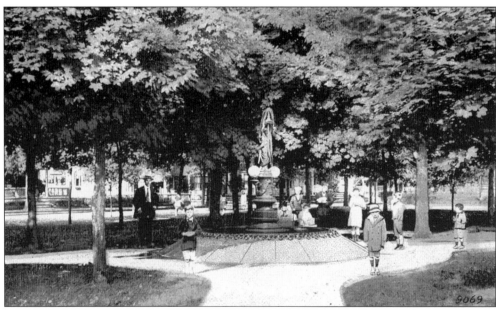

Woodlawn Park, now known as Fireman's Park, is located just inside the Main Avenue Gates of Ocean Grove. Just visible behind the trees in this white bordered–era view of the park, is one of Ocean Grove's first Craftsman-type houses, built *c.* 1920. Several of these homes were constructed in this time period when many larger hotels were destroyed by fire.

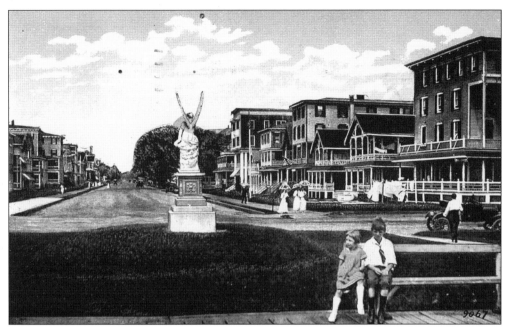

Located at the foot of Main Avenue, the Angel of Victory was dedicated as a memorial to Revolutionary War soldiers who died at the Battle of Monmouth. Destroyed during a winter storm, the statue is to be replaced thanks to a project being undertaken by the Historical Society of Ocean Grove.

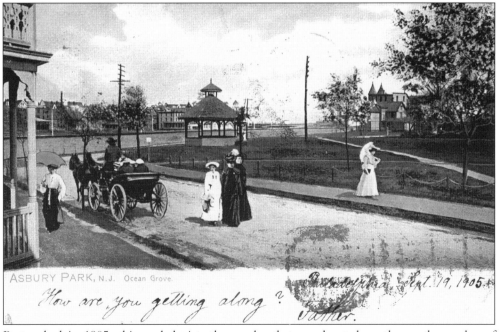

ASBURY PARK, N.J. Ocean Grove.

How are you getting along?
Father.

Postmarked in 1905, this card depicts the gazebo that was located on the northern edge of Founder's Park. Visitors to Ocean Grove likely enjoyed watching Wesley Lake from the shady perspective inside the gazebo.

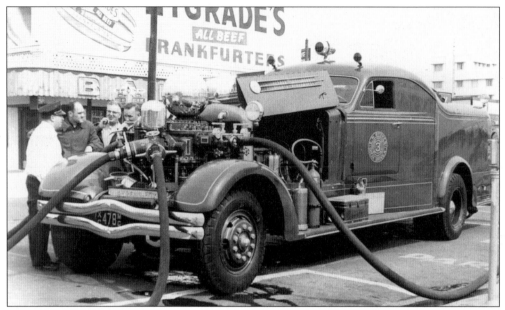

This 1,000-gallon Ahrens-Fox pumper engine was delivered to E.H. Stokes Fire Company 3 in 1939. It is shown here responding to a fire in Asbury Park. The man standing second from the left is Harry Eichorn, who joined the fire department in 1952.

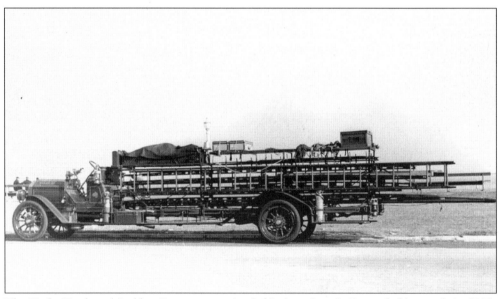

The Eagle Hook and Ladder Company received this American LaFrance ladder truck in 1912. With many three- to five-story buildings in Ocean Grove, ladder trucks are an important tool in fighting fires and rescuing victims. In 1909, Ocean Grove received the first motorized fire engine in New Jersey and, in the year this truck was delivered, became the first fully motorized fire department in the state.

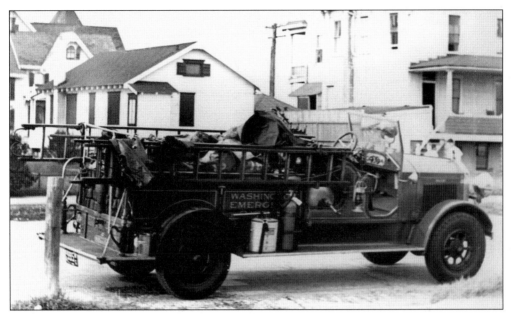

The Washington Fire Company's Maccar hose truck, used to carry fire hoses and other pertinent equipment, dates from the 1930s. Ocean Grove is unique in that it has three fire companies, Washington, E.H. Stokes, and Eagle Hook and Ladder. For a town that is less than one square mile, this may be a record for the relative amount of fire apparatus per capita.

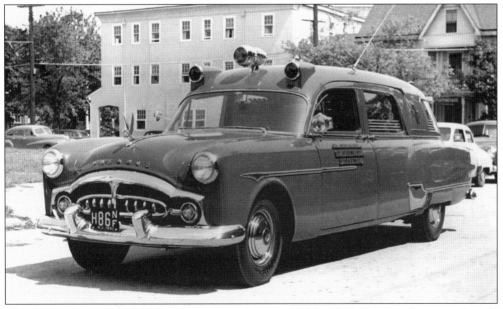

The Ocean Grove First Aid Squad was formally organized in 1932. Prior to that year, first aid equipment had been carried on the Stokes Company's trucks. This is the squad's 1951 Packard ambulance. Like the three fire companies, the first aid squad is completely volunteer and no members receive any compensation for their countless hours of service to the community.

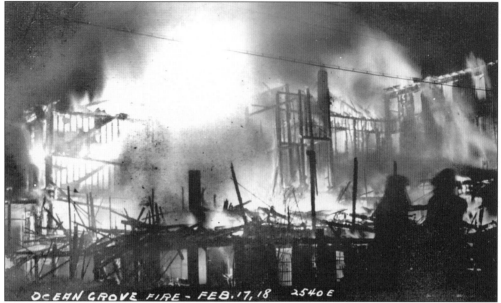

One of the early fires fought by the Ocean Grove fire departments occurred on February 17, 1918. Ocean Grove has some of the best-trained and most highly skilled firefighters. However, early building codes—since changed—made fighting some fires nearly impossible. This structure appears to have balloon-type framing, with wall studs that go from ground level up three or four stories, without any fire blocking, thus creating a chimney affect and causing a fire quickly to burn out of control.

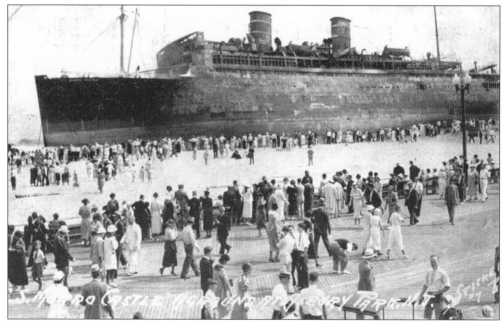

The *Morro Castle* passed Ocean Grove early one morning in September 1934 following a fire that claimed 137 passengers and crew on September 8, 1934—a fire that started just off Ocean Grove's portion of the Atlantic coastline. Many people were awakened that morning to the cry of "There's a ship burning off Ocean Pathway."

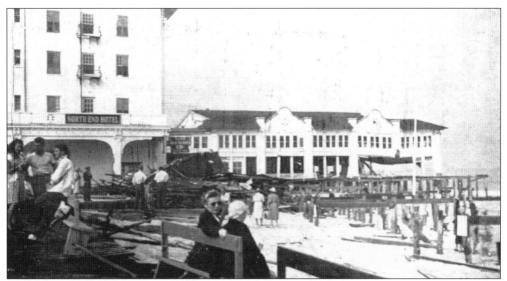

Hurricanes have always posed a great threat to the shore. Ocean Grove and the entire Jersey coast were pummeled by a hurricane on September 14, 1944. This card shows the damage done to the North End Pavilion; the scars of this damage are still visible today, as the curved roof pendants on the eastern half of the building stop midway. As this side of the building was often the most damaged, a decision was made to stop repairing it completely and just to shorten the building.

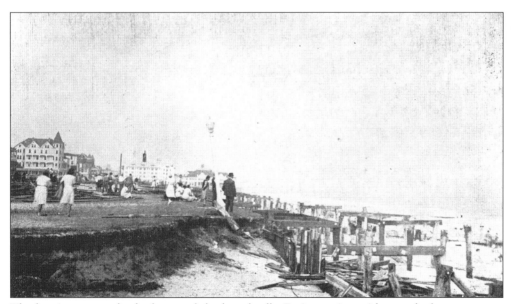

The hurricane completely destroyed the boardwalk. Entire sections either washed out to sea or were deposited by the waves on Ocean Avenue.

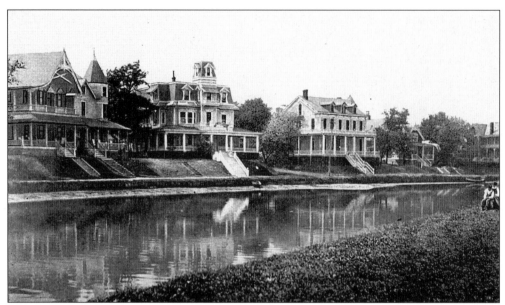

With their graceful stairs leading down to the banks of Wesley Lake, many of these fine Victorian homes have now been restored. The spirit of preservation, combined with the town's National and State Historic Site status, has lead to major portions of the town's original 19th-century housing stock being restored and renovated.

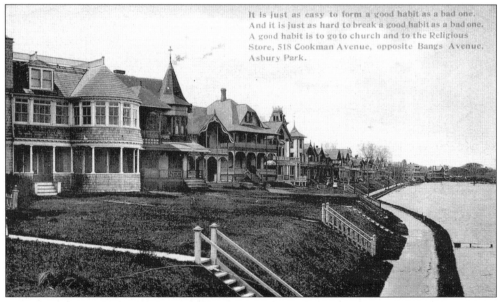

This rare Ocean Grove card features an advertisement for an Asbury Park business, "The Religious Store, 518 Cookman Avenue." It was not uncommon, particularly with Wesley Lake postcards, for the terms "Asbury Park" and "Ocean Grove" to be used indiscriminately and interchangeably on early postcards.

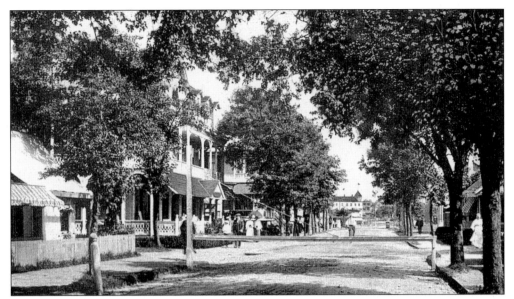

Misspellings are often seen in early postcards, including this one showing Pilgrim Pathway, as the card's publisher spelled it "Pilgrims Pathway." The gate blocking the street, sending traffic down Bath Avenue, was used to prevent vehicular disturbances during weekday services in the Great Auditorium.

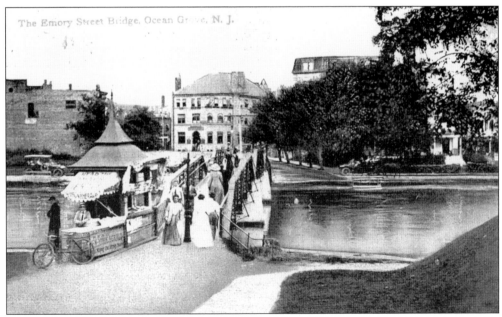

The Emory Street Bridge, Ocean Grove, N. J.

This view looks north across the Emory Street bridge, showing the original Asbury Park post office in the rear. The newspaper booth in the image, selling the *New York Herald,* was likely one of the original tollbooths from the early days of the Camp Meeting Association. This stand was closed on Sundays in compliance with the Ocean Grove regulation.

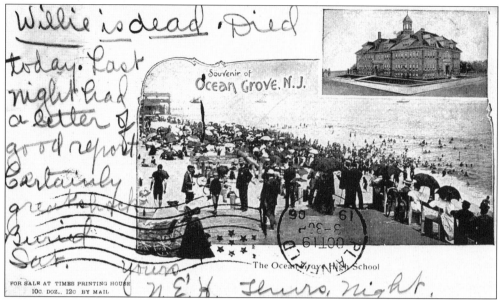

Private mailing cards were first authorized by an act of Congress on May 19, 1898. This one is postmarked October 19, 1906, and was sent to Plainfield. It shows the North End Beach and Neptune High School. As messages were only permitted on the front of the mailing cards, our vacationer wrote, "Willie is dead. Died today. Last night had a letter of good report. Certainly great shock. Buried Sat. Yours, N.E.H. Thurs. night."

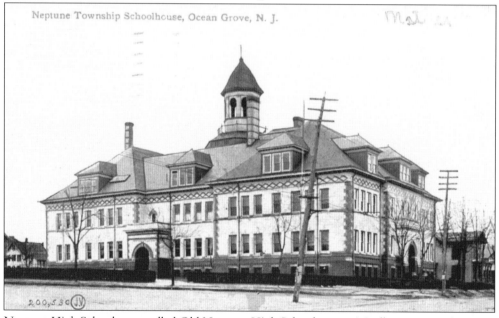

Neptune High School, now called Old Neptune High School, was originally constructed in 1898 and served as the educational center of the township until 1960, when a new Neptune High School began operation some three miles west on Neptune Boulevard. The building's design won highest honors at the World's Fair in Chicago. Thanks to many dedicated volunteers, this building has been brought back from a long-neglected and abandoned state to become a positive nonprofit community arts center.

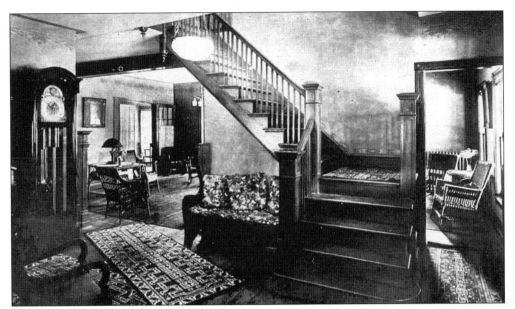

This is a rare interior view of one of Ocean Grove's first nursing homes, the Bancroft Taylor Rest Home, located at 74 Cookman Avenue. Today, Ocean Grove's newest nursing home, Manor-by-the-Sea, draws from Ocean Grove's rich Victorian heritage and boasts an interior as inviting as this image. The building is so attractive on the exterior and in the lobby that tourists often stop and inquire about the facility, thinking it is a hotel.

This is a later exterior view of the same facility, which was demolished in 2001. Plans are being considered to construct new senior housing on the site.

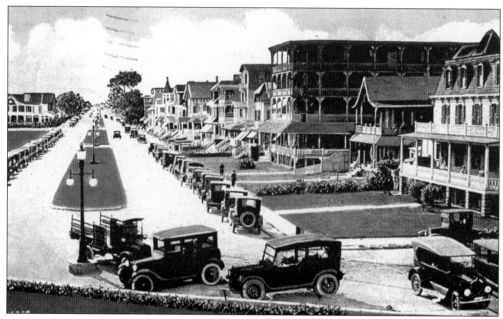

People often grumble that new, larger, automobiles such as sports utility vehicles are to blame for a lack of parking space in Ocean Grove. However, this card showing Broadway, postmarked in 1927, tells us that parking has been at a premium in Ocean Grove since the dawn of the horseless carriage.

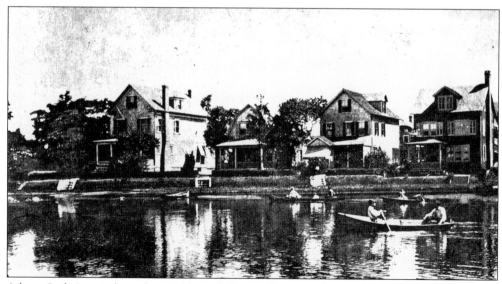

Asbury Park is not the only neighbor of Ocean Grove to share a Methodist and geographic heritage. To the south is Bradley Beach, James Bradley's "other" family resort. Shown here are some of the many Victorian homes located on the Bradley Beach side of Fletcher Lake.

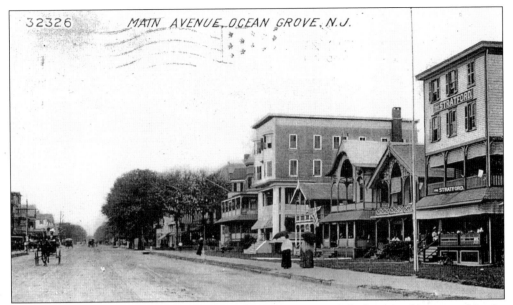

If it were not for the women's dress in the right of the card, and the horse and buggy making its way east on Main Avenue, this image could have been taken recently. This is a true testament to how much of Ocean Grove's Victorian heritage has been preserved and to the treasure of Victorian architecture it represents.

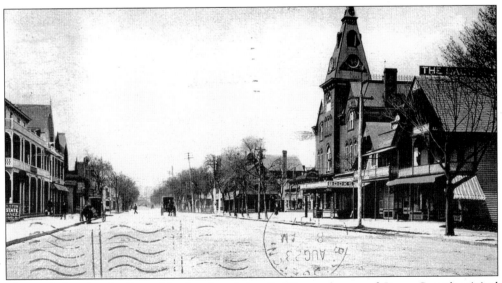

This card, showing the Camp Meeting Association Building and many of Ocean Grove's original shops, has a mistake. The caption on the card reads "Street" instead of "Avenue." In fact, Ocean Grove has only two official streets: Olin Street and McClintock Street. All others are avenues or ways.

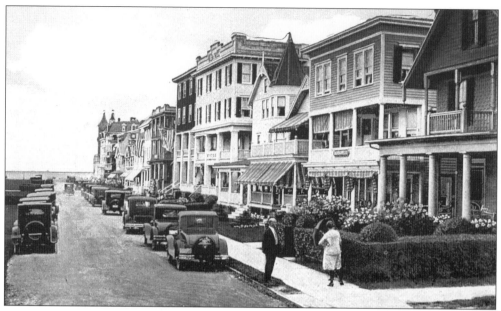

Many have called Ocean Pathway the "prettiest street in America," and this view shows some of the numerous Victorian structures that support this statement. Many of the original slate curbs, sidewalks, and pipe rail fences are still in place throughout the town.

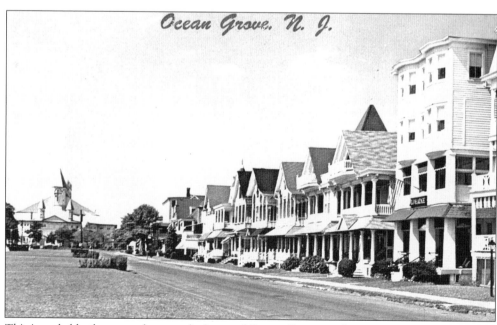

This is probably the most photographed area of Ocean Grove, with its mixture of Queen Anne, Stick, and Cottage-Carpenter houses. Judging from the fact that no cars are present on Ocean Pathway, it was likely taken just before the Sunday No Parking law was repealed.

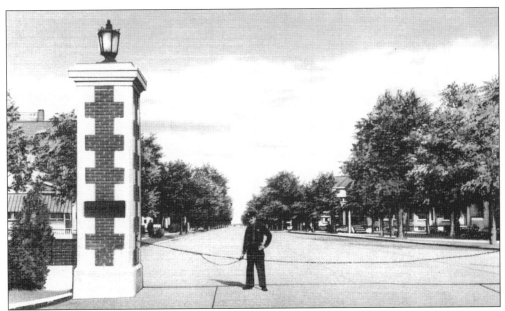

The main gateway into Ocean Grove, with the image of a chain and a policeman, brings back memories of a car-less community, where for 117 years, on Sunday, no horse-drawn buggies or automobiles were allowed on the street except for emergencies. The brick-and-sandstone pillars were constructed in 1916, replacing swinging gates. The bronze plaques, one on each pillar, are inscribed, "ENTER INTO HIS GATES WITH THANKSGIVING" and "AND INTO HIS COURTS WITH PRAISE." These are the keynotes of Ocean Grove's welcome to all.

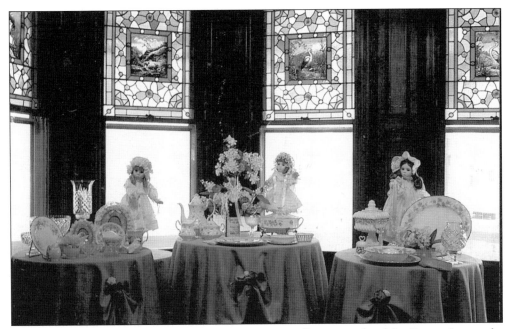

The Clayton House, located on Main Avenue, is an excellent example of the Queen Anne style, with imported German stained-glass windows, carved oak entrance doors, wraparound porch, and slate roofing. Today, it houses Gifts by Tina, with collectible dolls being the main feature.

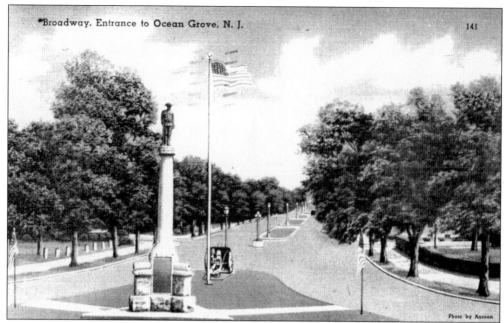

Photo by Aareen

This was the original Veterans Memorial erected at the Broadway entrance to Ocean Grove to commemorate those who served in World War I. Later, an additional granite monument was installed to commemorate those who served in World War II. The howitzer cannon was removed to accommodate the additional war monument, which now includes a POW-MIA (prisoner of war–missing in action) flag.

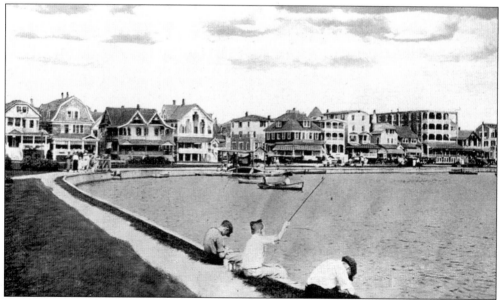

Throughout Ocean Grove's history, fishing has been a popular recreational activity, especially with the Atlantic Ocean and Wesley and Fletcher Lakes on three sides of the town. Ocean Grove is nearly an island. These two children may be practicing for one of the Fletcher Lake fishing contests sponsored in part by the late Mary Elizabeth Jenkins. Prizes were awarded for novel categories like prettiest fish, ugliest fish, and least number of fish caught.

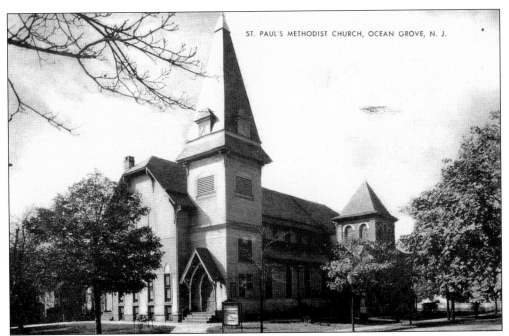

ST. PAUL'S METHODIST CHURCH, OCEAN GROVE, N. J.

In 1882, St. Paul's Church was located at the head of Main Avenue on the lots where the old Neptune High School is now located. In an arrangement with the Ocean Grove Camp Meeting Association, the church relocated to Park Square, a full block of land on New York and Embury Avenues. This card shows St. Paul's before 1959, when the sanctuary was enlarged and additional Sunday school rooms were added. The simple design of the stained-glass windows in St. Paul's convey a strong statement of belief.

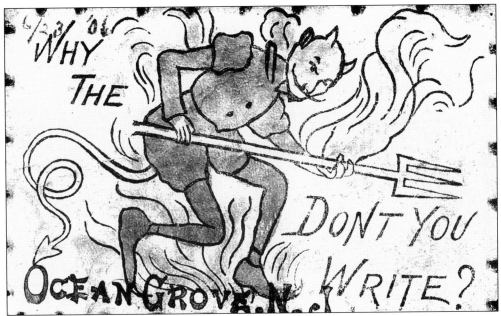

Not all postcards were printed on paper. This rare card is printed on leather and poses the risqué question "Why the —— don't you write?"

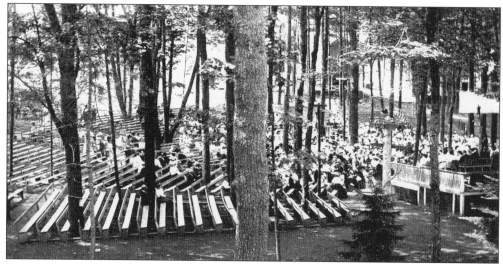

Researchers have found references to more than 2,000 camp meetings and camp meeting grounds. Almost all were based on the concept of a preacher's stand in the woods or tent with an amphitheater for perhaps 1,000 to 2,000 sinners eager to hear the message of salvation. This postcard from Ocean Grove in Harwich Port, Massachusetts, is an example of the Ocean Grove influence on camp meetings. The postcard, mailed in 1908, illustrates the half-circle assembly with benches. The message reads, "Have been to Old Orchard [a camp meeting in Maine]. Want to tell you about it. Am sorry not to get to Ocean Grove. This is where the meetings are held in the grove except when stormy."

The Reverend William B. Osborn, the founder of Ocean Grove, traveled around the world to establish other camp meeting grounds. This picture card from Ocean Grove, Victoria, in Australia, courtesy of Mary Randall, illustrates Osborn's ability to select ideal recreational locations that supported religious programs.

Four

THE CAMPGROUNDS

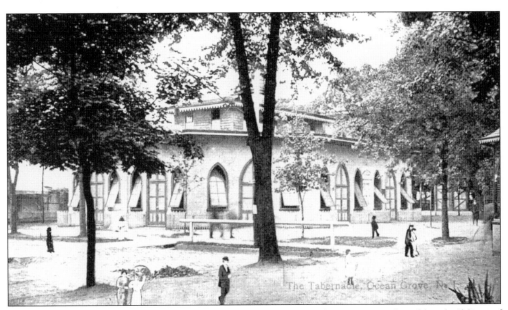

The Tabernacle, dedicated as a memorial to Bishop Edmund S. Janes, is the oldest building of continuous worship in Ocean Grove, having been constructed in 1877. Despite the serious nature of the sermons being spoken from the marble-and-oak pulpit, the lithographer has inserted his humor into this image. Notice the "little people." All the faithful in this card appear to be about one foot tall.

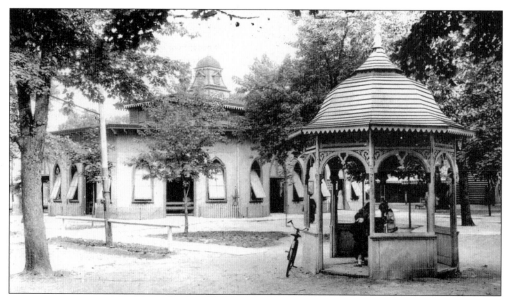

An important aspect for a successful camp meeting was having plenty of fresh water for drinking and bathing, and Ocean Grove was famous for having many public wells throughout town. The Beersheba well was erected to commemorate the place water was first found in Ocean Grove. Today, Beersheba serves as a drinking fountain and as the official symbol of the Historical Society of Ocean Grove. It is maintained by local builder John Case as his gift to the community.

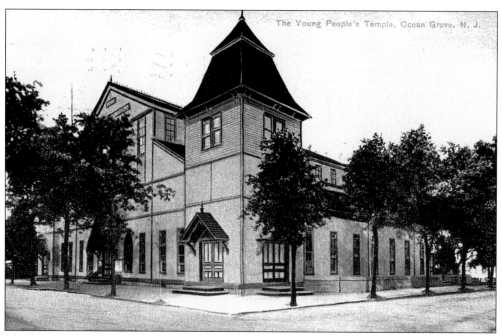

The Young Peoples Temple was the center for the Camp Meeting Association's children's and youth programs. The Youth Temple was designed by Ocean Grove's first police chief, Major John Patterson. It was built at a cost $7,500, was dedicated in 1887, and was large enough to seat 1,500. The Youth Temple was destroyed by fire in June 1977.

Several cards contain poems and printed songs with messages of love for Ocean Grove and its beauty. "The Temple Smile Song," with lyrics by Marie Graham and sung to the tune "There Is a Tavern in Our Town," is a bit unusual considering the Camp Meeting Association's well-known stand against the consumption of alcoholic beverages.

"TEMPLE SMILE SONG"

Young People's Temple of Ocean Grove, N. J.
Tune: "There is a Tavern in Our Town."

Words by Marie Graham

There is a temple in the town, in the town,
And there the people come around, come around,
To join in songs of praise and melody,
And learn to live in harmony.

CHORUS.

Dr. Mead, he is the leader; Tali Morgan leads us, too,
And between these two great leaders, we have all
 that we can do.
: To smile, and smile, and smile, and smile, and
 smile, and smile, :
But we have left our cares at the bottom of the sea,
And so our hearts are light and free.

There is with us a singer grand, singer grand,
Whose songs are greatly in demand, in demand,
Join in the chorus of number forty-one;
Don Chalmers' reign has now begun.
 Chorus

Good morning, friends, we're glad to say, we're
 glad to say,
We're here to drive the blues away, the blues away,
We'll make it sweet while here we meet,

Using the biblical story of Nehemiah as inspiration, the Camp Meeting Association began a fund-raising campaign in earnest in 1999 to raise funds to replace the Youth Temple. The new state-of-the-art facility has two large multipurpose rooms, with the first floor being both a theater and gymnasium. Also on the lower level are classrooms, kitchen facilities, and office space. The two towers, designed to echo the original Youth Temple, are used for Bible study and group seminars.

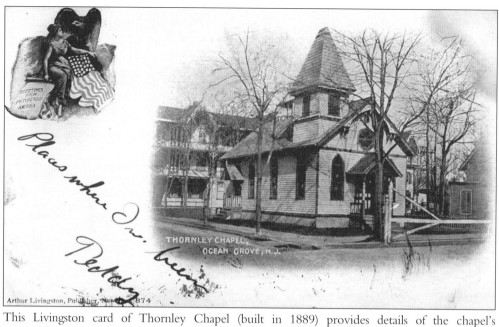

This Livingston card of Thornley Chapel (built in 1889) provides details of the chapel's surroundings. Note the swing gate, the trees along the curb, and the picket fence on the right. The building was a memorial to the Reverend Joseph H. Thornley, one of the original charter members, and was built at a cost of $1,299.58, including furniture, organ, and stained-glass windows.

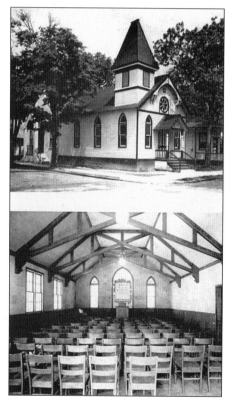

Thornley Chapel still functions for "Ocean Grove's Famous Children's Meeting," held daily at 9:00 a.m. and Sundays from 9:00 a.m. to 2:30 p.m. for boys and girls ages up to 12 years. The exterior changes include the removal of the swing gate, two trees, and the picket fence and the addition of the Spanish-style annex on the back left and the small Telegraph Building on the right.

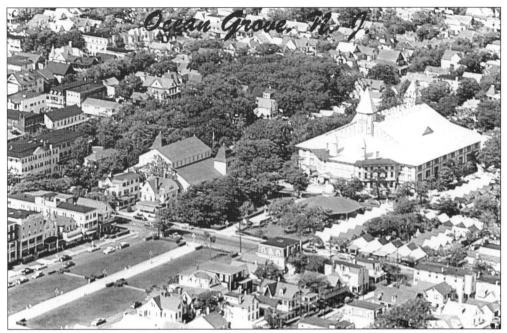

This general overview of the camp meeting grounds shows the Great Auditorium, the Temple, the Jerusalem Pavilion, and the tent community.

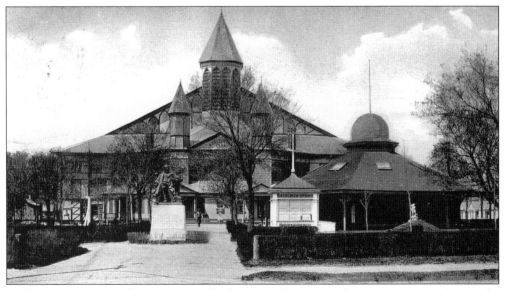

In this exterior view of the Great Auditorium, two features no longer present are shown: the statue-fountain of Jennie and Joe, which was originally located at the foot of Main Avenue, and the Excelsior Spring, a natural springwater concession that also had a stand on the boardwalk.

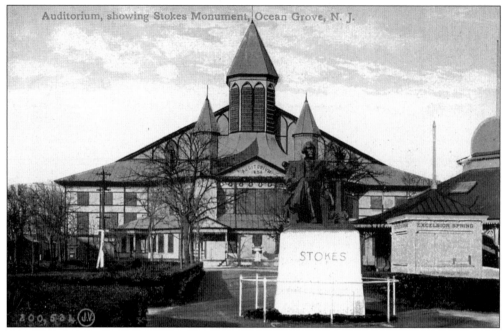

This heroic-sized bronze statue of Dr. Ellwood Stokes was cast by sculptor Paul W. Morris. Installed in 1905, it is a memorial to Stokes, who was the Camp Meeting Association's first president. A close look at this card shows the trees are bare, meaning that the picture was taken during the winter. For many years, it was the practice to shutter all windows on the Great Auditorium and other Camp Meeting Association facilities during the winter.

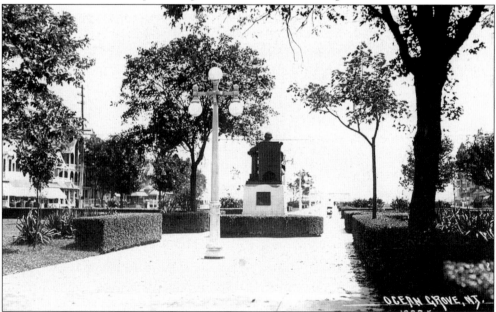

This unique view shows the rear of the Stokes memorial statue and the plaque on the back of the granite base, which reads, "Ellwood H. Stokes Born October 10, 1814. The Ocean Grove Camp Meeting Association was chartered March 3 1870. Dr. Stokes was chosen president and remained until the time of his death. July 16, 1897."

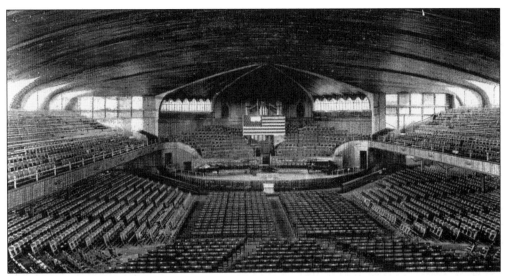

Completed in 1894 and taking 90 working days to construct, the Great Auditorium has been the center of Ocean Grove since the day it was erected. Designed by architect Frederick T. Camp, it is one of the largest wood-frame structures still surviving.

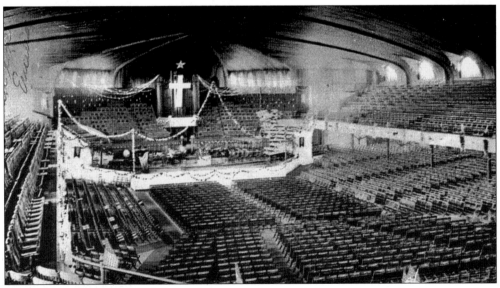

It was Frederick T. Camp's design to have an unobstructed view of the preacher from anywhere in the 9,000-seat building. The efficient use of space for the congregation is evident in the radiating pattern of the seats on the main floor of the Great Auditorium. The preacher's word would go to the people and continue past the sliding barn doors of the Great Auditorium into the world, preaching the message of Christian salvation to all.

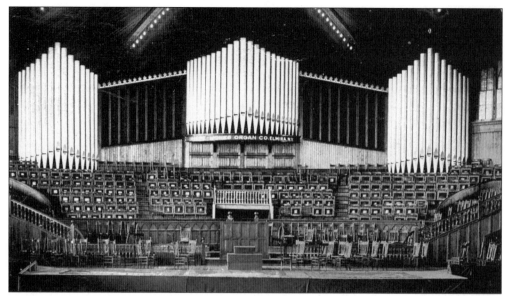

In 1907, Tali Esen Morgan and the Camp Meeting Association chose Robert Hope-Jones, the father of modern pipe organ building, to install a new pipe organ in the Great Auditorium. The new Hope-Jones organ replaced an older one donated by the Washington Square Methodist Episcopal Church in New York City. This organ was moved across the street to the Youth Temple. Shown are the golden facade pipes installed in 1907, along with the advertisement for the Hope-Jones Organ Company of Elmira, New York, in the center of the organ case.

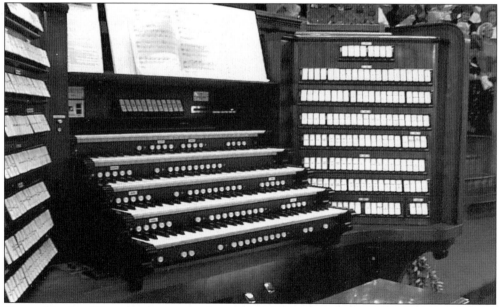

Pictured is the fifth and present console to control the Hope-Jones organ. The console was originally installed at Longwood Gardens in Kennett Square, Pennsylvania, and was eventually removed from that location. Forgotten for nearly 25 years, the console was found in a dilapidated Philadelphia warehouse and purchased by present organ curator, John R. Shaw. Shaw restored the solid walnut console and installed it as a memorial to Josephine Eddowes, who was the Great Auditorium organist from 1946 to 1965.

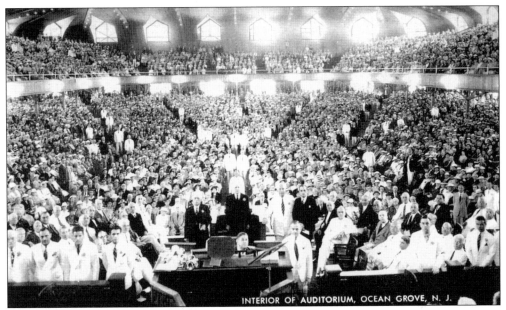

INTERIOR OF AUDITORIUM, OCEAN GROVE, N. J.

Shown are Sunday services in the Great Auditorium, with Clarence Kohlman at the console of the organ. Kohlman served as the Great Auditorium organist from 1924 to 1945. He was the composer of the famed "Great Auditorium Ushers' March." In this photograph, the ushers, recognizable in their white jackets, stand ready for the signal to be given to march to the altar rail with the service's offerings.

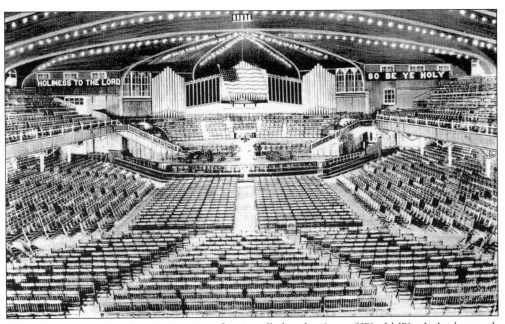

This picture shows the electric American flag, installed at the time of World War I. At the touch of a button, the flag lights and blinks as though it is waving in a strong breeze. This flag was replaced with a replica in 2001. The new flag is removed for Sunday church services, exposing a walnut cross with gold leaf accents.

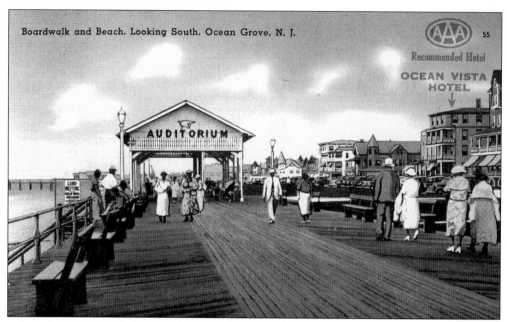

Advertising and promotion are important factors in the success of Ocean Grove. Here, a hand pointing westward toward the Great Auditorium, combined with the word "Auditorium," points out this important landmark to visitors who may just be strolling through. (This pavilion is also discussed on page 51.)

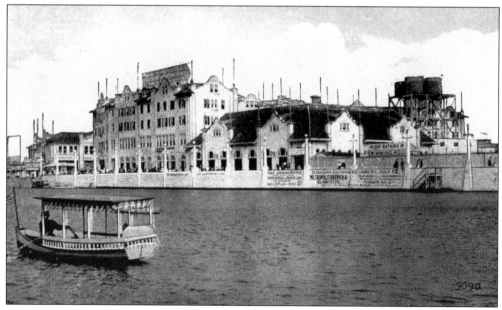

It was the custom to paint word of the various events on the Wesley Lake retaining wall on the Ocean Grove side, facing Asbury Park. This card shows that the Metropolitan Opera Quartet was scheduled to appear on Saturday, July 12, in the Great Auditorium.

The Japanese Girl's Chorus, Ocean Grove, N. J.

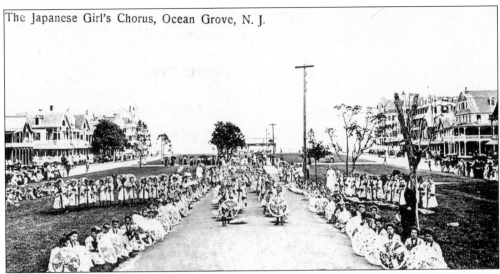

Tali Esen Morgan was not only a master conductor but also a great showman who produced outstanding youth programs and children's choruses. The kimono girls were part of the Children's Fairyland Festival, for which the Great Auditorium was magically transformed into a vast fairyland garden of Chinese lanterns, colored strips of glass beads and ribbons against a backdrop of rocks and mountains. The queen and her royal court would make a grand entrance, along with 700 to 800 of her loyal subjects. The program was broken into three parts: a limited concert of solos or small groups, the coronation of Queen Mab III, and a grand patriotic finale of American songs.

The Rough Riders, named in honor of Theodore Roosevelt, were Ocean Grove's solution to unruly little choirboys. The group was formed to give the 300 children a structured environment and to relieve the four policemen who were assigned to keep order during the choir rehearsal. As soldiers, the children enforced their own discipline. Benefits included rations of cookies, milk, and ice cream, as well as the chance for an overnight bivouac in the Great Auditorium.

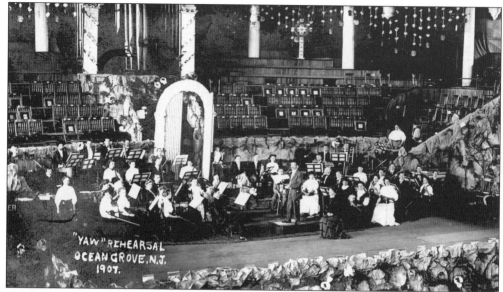

This rare card shows an orchestra rehearsal being directed by Tali Esen Morgan, who is standing in the center of the image at the conductor's stand. The main permanent platform of the Great Auditorium is rather small, designed to accommodate the people for a church service. For larger religious and secular productions, a stage extension must be utilized. Today, the Great Auditorium uses the most modern staging equipment, including a moveable stage section between the altar rail and main platform.

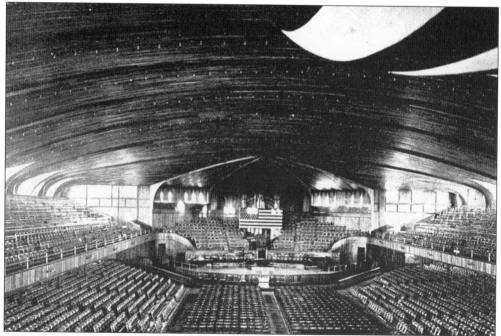

This rare real-photo postcard shows the interior of the Great Auditorium with the choir loft before it was modified to allow the installation of the Hope-Jones organ. This card's sender mentions seeing Pres. Theodore Roosevelt speak to the teachers at the National Education Association conference at Ocean Grove.

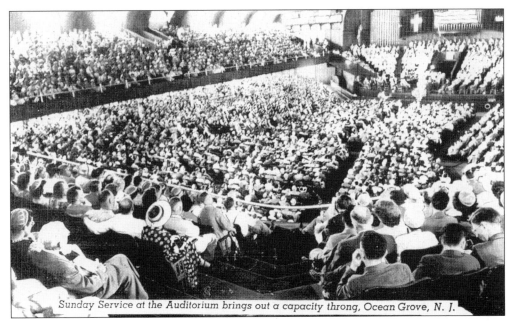

Sunday Service at the Auditorium brings out a capacity throng, Ocean Grove, N. J.

The Great Auditorium often had full capacity crowds of more than 7,000 people. All these patrons were served by only five women's toilets and three men's (the waiting line must have been something). Fortunately, a new large comfort station was built across the street in 1993. Many locals refer to it as "St. Johns."

The Reverend Billy Sunday, who preached in Ocean Grove during the early part of the 20th century, left his career as a professional baseball player to become a preacher. His evangelical career started in 1891 and continued until the time of his death in 1935.

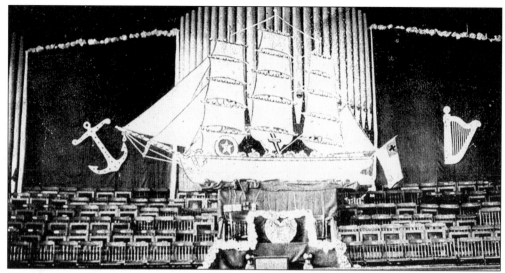

This is a scene from *Voyage of Life,* one of the early children's shows in the Great Auditorium. Upon closer inspection, this sailing ship appears to be outlined in electric lights and numerous wires lead up to the deck on the ship's hull. This is likely one of the "spectacular electrical effects" created by one of the Great Auditorium's early employees.

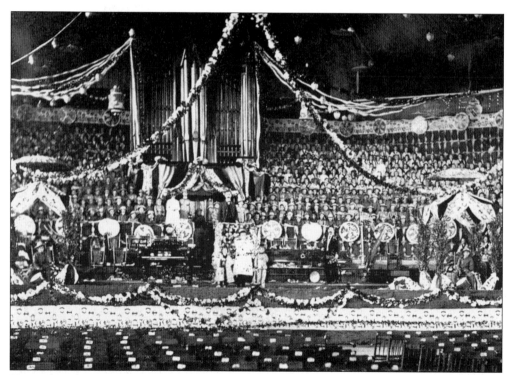

Pictured in this pre–Hope-Jones organ view is one of Tali Esen Morgan's legendary children's shows, with the Great Auditorium lavishly decorated on the stage and choir loft. Morgan's casts often involved more than 500 children at a time.

Popular entertainment has always been a feature of both resorts, and at the beginning of the 20th century, bandleader John Philip Sousa was often an attraction in both towns. One of his most gifted musicians, Arthur Pryor, is shown here after he left Sousa to pursue his own band, which played regularly in the Asbury Park Casino and Arcade. Latching onto the new technology of recorded music, Pryor became the first musician to make a living solely on recordings, retiring for much of the 1930s and 1940s. He came out of retirement in 1945 in an effort to boost local morale as a result of World War II. His final concert run was cut short when he suffered a stroke and died just after Labor Day 1945.

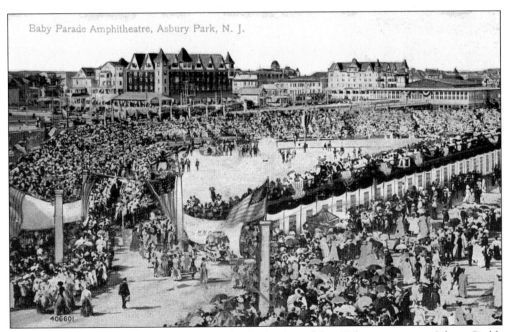

One of the area's most popular events at the beginning of the 20th century was Asbury Park's baby parade. In the early days of the parade, as shown in this postcard, the musical and artistic director was Ocean Grove's Tali Esen Morgan.

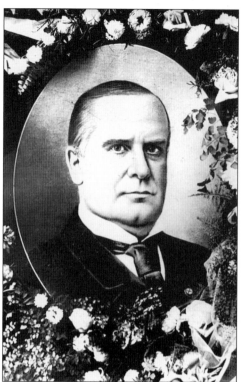

William McKinley, the 25th president of the United States, gave a speech from the dais of the Great Auditorium in the summer of 1899. Two years later, in September 1901, he was assassinated. This card was produced to commemorate his tragic death.

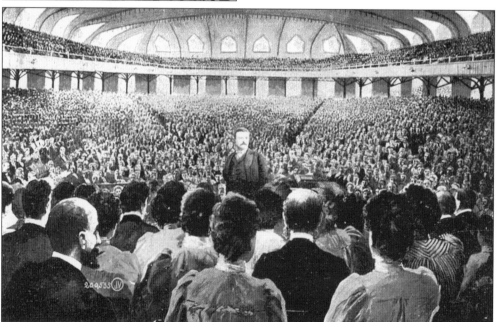

This postcard shows Pres. Theodore Roosevelt addressing the National Education Association in the Great Auditorium on July 7, 1905. An interesting side note to these cards is that as different presidents appeared at the Great Auditorium, the producers of the postcards merely switched the president's heads during the lithography process used to create the card; the audience remained the same.

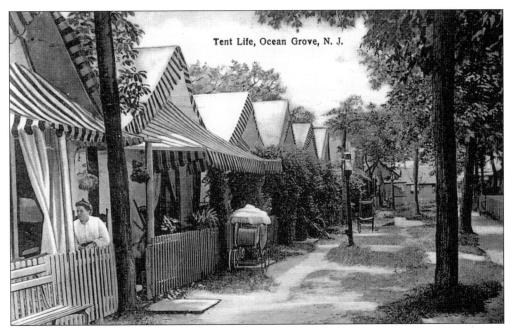

The love of tenting goes beyond the romantic image. Some families are fifth-generation tenters with no thought of giving up these unique structures. Yes, they do have hot and cold water, showers, toilets, refrigerators, television sets, and even one with a bathtub. They are occupied from May 15 to September 15 by people who think tent life is grand.

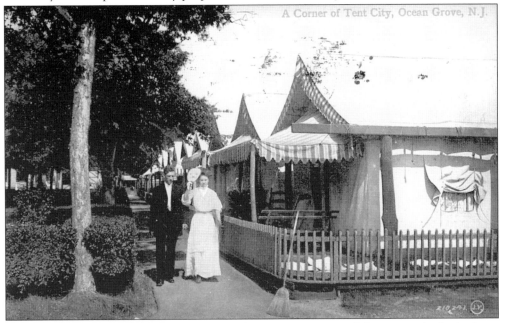

There are only 114 tents left from the original 700. Some tents and the cottage in the back, or shanty if you will, gradually evolved to more permanent year-round structures, which then grew to larger homes and even hotels. It should be noted that in Ocean Grove, very few floors are level and not many walls are exactly vertical. Standing on the walkway are Walter and Caroline Scott of Kearny, spending their honeymoon in Ocean Grove.

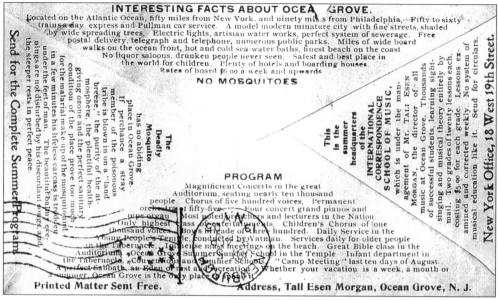

INTERESTING FACTS ABOUT OCEA GROVE.

Located on the Atlantic Ocean, fifty miles from New York, and ninety miles from Philadelphia. Fifty to sixty trains a day, express and Pullman car service. A model modern miniature city with fine streets, shaded by wide spreading trees. Electric lights, artisian water works, perfect system of sewerage. Free postal delivery, telegraph and telephone, numerous public parks. Miles of wide board walks on the ocean front, hot and cold sea-water baths, finest beach on the coast No liquor saloons, drunken people never seen. Safest and best place in the world for children. Plenty of hotels and boarding houses. Rates of board $6.00 a week and upwards

NO MOSQUITOES

Send for the Complete Summer Program

The Deadly Mosquito has no abiding place in Ocean Grove. If perchance a stray member of the poisonous tribe is blown in on a "land breeze," the purity of the atmosphere, the plentiful health-giving ozone and the perfect sanitary condition of the place prove too much for the malarial make-up of the mosquito, and in a few minutes his lifeless carcass is trolley under the feet of man. The beautiful baby ever sings are not disturbed by his discordant songs, and the sleeper rests in perfect peace.

This is the summer headquarters of the INTERNATIONAL CORRESPONDENCE SCHOOL OF MUSIC, which is under the management of Mr. TALI ESEN MORGAN, the director of all music at Ocean Grove. Thousands of successful students, learning sight-singing and musical theory entirely by mail. Two grades of twenty lessons each, costing $5.00 for each grade. Lessons examined and corrected weekly. No system of musical education like it. Send for circulars.

New York Office, 18 West 19th Street.

PROGRAM

Magnificent Concerts in the great Auditorium, seating nearly ten thousand people. Chorus of five hundred voices. Permanent orchestra of fifty-five. Four concert grand pianos and pipe organ. Most noted preachers and lecturers in the Nation. Only highest class of entertainments. Children's Chorus of one thousand voices. Boys' Brigade of three hundred. Daily Service in the Young People's Temple, conducted by Yatman. Services daily for older people in the Tabernacle. Immense mass meetings on the beach. Great Bible class in the Auditorium. Ocean Grove Summer Sunday School in the Temple. Infant department in the Tabernacle. Conventions and Summer Schools. "Camp Meeting" last ten days of August. A perfect Sabbath, an Eden of rest and recreation. Whether your vacation is a week, a month or a summer, Ocean Grove is the only place to spend it.

Printed Matter Sent Free. **Address, Tali Esen Morgan, Ocean Grove, N. J.**

This rare card-envelope by Tali Esen Morgan illustrates the advertising methods that he developed to attract people to the Camp Meeting Association music programs. Ocean Grove was known as a delightful seashore community without the dreaded Jersey mosquito.

My wife's joined the Suffrage Movement,
(I've suffered ever since!)

Comic cards were always popular. Ocean Grove was one of the state leaders in both the suffrage and temperance movements.

The original Camp Meeting Association offices were located on Main Avenue. In addition to housing these offices, the building at one time also held the town's jail cell, Archie Griffith's sign shop, and the post office. Although the Camp Meeting Association has moved to newer headquarters on Pitman Avenue, the post office is still in this building.

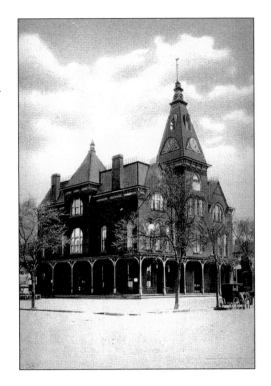

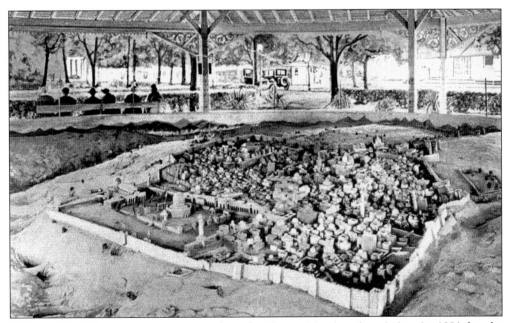

This model of Jerusalem was presented to the Camp Meeting Association in 1881 by the Reverend W.W. Wythe, M.D. Wythe created the model based on numerous visits to the actual city of Jerusalem. The accurate scale model required a great deal of upkeep; eventually it became unfeasible to repair, and it was removed *c.* 1950. The pavilion built to protect the model in 1885 still stands and is used for town bazaars, book sales, and other community activities.

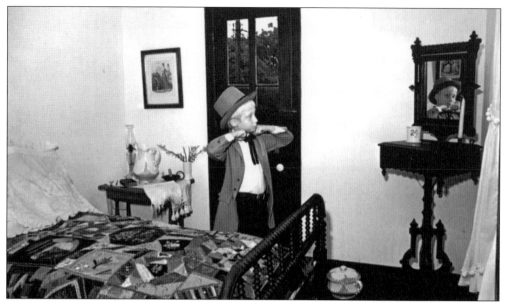

The Historical Society of Ocean Grove has preserved Centennial Cottage, a gift of Robert and Mary Scold, as a historic cottage. The structure was moved from its original location at 47 Cookman Avenue to the present location of Central Avenue and McClintock Street. Shown here is Chip Holmes, dressed in period costume, adjusting his collar before leaving for children's Sunday school.

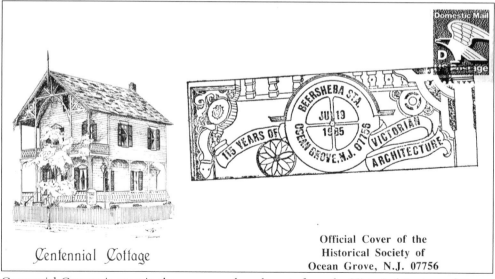

Centennial Cottage is open in the summer when docents from the Historical Society of Ocean Grove give 45-minute tours of the various rooms. The collection of Victorian furniture, clothing, and Ocean Grove memorabilia is restricted to the 1870–1900 period. This is an example of one of 20 first-day covers issued by the historical society in cooperation with the post office.

Five

WHERE PEOPLE
SLEPT AND DINED

IMPORTANT

AUTOMOBILES

Ocean Grove is a Christian center which strictly observes Sunday as the Lord's Day, a Day of Rest and Worship. No auto-mobiles are allowed in the Grove between mid-night Saturday and mid-night Sunday. Cars may be parked at the Southwest end of town. All cars must be out mid-night Saturday or they will be towed out and suffer towing charges and a fine.

It is the responsibility of Hotels and Rooming Houses to see to it that every patron receives this notice.

OCEAN GROVE POLICE DEPARTMENT

For 117 years, no horse-drawn buggies or automobiles were permitted in Ocean Grove on Sunday. This card was placed in each hotel room as a reminder of the rules and regulations of the Camp Meeting Association. This restriction helped to establish Ocean Grove's reputation as a strict religious community to the point that it was often nicknamed "Ocean Grave." The rule also helped to preserve the Victorian structures on the 350 acres of Camp Meeting Association grounds by discouraging development tied to the use of an automobile.

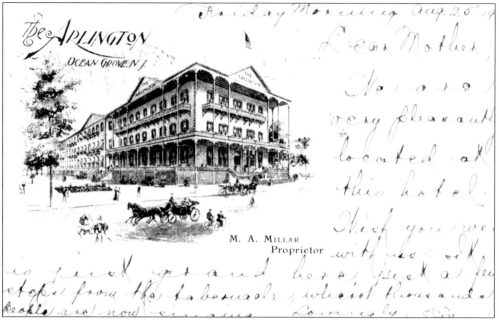

The Arlington Hotel was one of the largest hotels in Ocean Grove. The three-story hotel, with a 250-person capacity, occupied the entire block of Central Avenue, Pilgrim Pathway, McClintock Street, and Pitman Avenue. It was removed in the 1950s to allow the construction of Arlington Court Apartments, with units of one and two bedrooms, one of the first Jersey Shore age-restricted condominium projects.

The Omaha stands at the corner of Central and Pitman Avenues. There is a strong Victorian Italianate design in the three-story hotel, with a cupola toward the front and side dormers toward the back. The cupola and the second-floor exhibit decorative quoins at the corners, an unusual feature. A round four-panel window with modified mansard trim is positioned under the eave, probably for attic ventilation. A pent between the first and second floors provides protection from rainwater from the second floor, as well as shade from the sun for patrons rocking on the first-floor porch.

The New Philadelphia, at 4 Ocean Pathway, is the first house from the ocean. The four-story hotel, with a 100-person capacity, appears to be on a typical Ocean Grove lot of 30 feet in width. The plain balusters on the first floor are in contrast to the square "Chinese Chippendale" railings on the second and third floors. Spandrel brackets and spandrels, attached to the turned porch columns, connect the space between the center double set of columns.

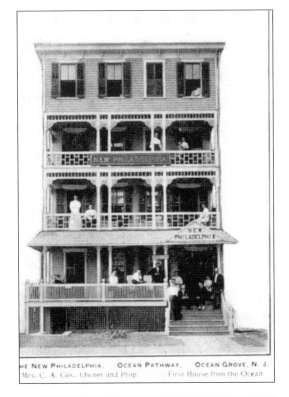

HE NEW PHILADELPHIA, OCEAN PATHWAY, OCEAN GROVE, N. J.
Mrs. C. A. Cox, Owner and Prop. First House from the Ocean

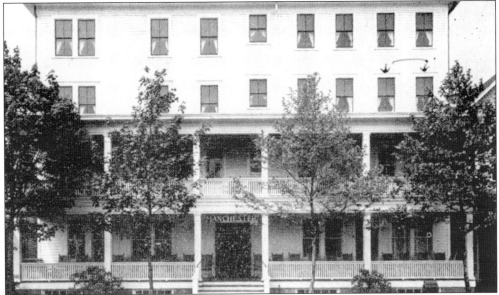

Hotel Manchester, at 25–27 Ocean Pathway, stands on two 30-foot lots. Two single homes were combined to form the present facade. The alley space between the two homes became the center stairway to the second- and third-floor rooms of the new hotel. A message to Haddonfield reads, "July 4—what a glorious breeze and we are enjoying it. Coats and blankets are in the order. We expect to be home Sat. in the early evening. I hope you have a nice holiday." The arrows indicate the rooms in which they were staying.

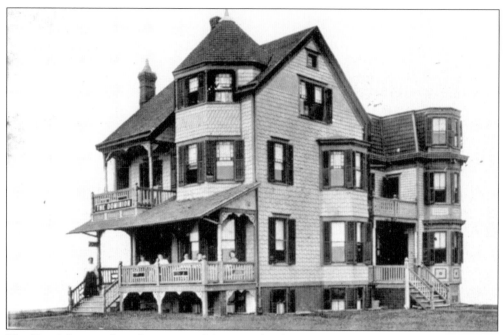

The Dominion stands at the corner of Ocean and Atlantic Avenues. The proprietors are Stroh and Yetter. This house exhibits various architectural forms: a rear mansard roof, two stories of bay windows on the side, a Queen Anne turret, small colored-glass panes around the windows, a broken roofline, a veranda, and fancy scrollwork under the first-floor porch.

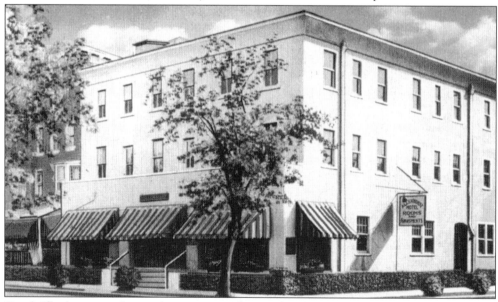

Hotel Allenhurst, on the southeast corner of Central and Pitman Avenues, has a 100-person capacity, modern rooms, and apartments. Under the ownership and management of G.F. Drake, the hotel is open from May to October. The card, postmarked September 1943, was sent to Lititz, Pennsylvania: "Well, we got here at 3 o'clock and had a pleasant drive. This is the place we are rooming and are taking our meals across the street from here both are very nice places. Close to the boardwalk and tabernacle—from the girls."

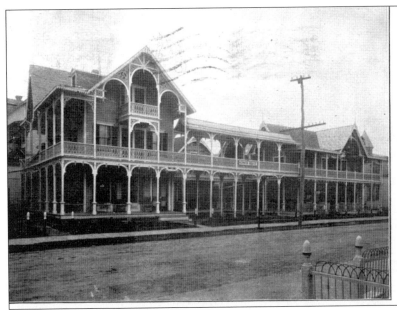

Norman House

28-34 Bath Ave.,
OCEAN GROVE,
N. J.

Terms to May 30th - - - $5.00 per week
" " June 30th - - - - 7.00 " "
" " July 30th - - - - 8.00 " "
" " Aug. 30th - - - 10. to 15. " "
Terms by the day 1.50 to 2.00
Norman House stage meets all trains

The Norman House stands at 28–34 Bath Avenue, a most unusual hotel with a first- and second-floor covered breezeway. Its proprietor is Mrs. C.R. Priest, and its capacity 125 guests. This card was sent to Middletown, New York, with the following message: "Dear Anita, Your welcome letter received. You too have been having hot weather. It is lovely here. The ocean is grand but I have not had the courage to take a dip yet. We go home 19th Monday. With a great deal of love, Aunt Barrie."

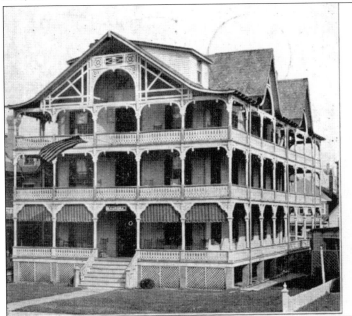

Telephone 5579

The

AURORA

Frank Ives Bull

Six Atlantic Avenue

Running Through to
Surf Avenue

Ocean Grove

New Jersey

Hot and Cold
Running Water

Full View of the Ocean

The Aurora, on four lots at 5 Surf Avenue, is an outstanding example of the Seashore Carpenter Gothic style, with its three stories of columns and pierced balusters. The card was sent to Elizabethtown, Pennsylvania, in 1944, noting, "I surely appreciate all your cards. I'm wishing you all a fine Love Offering Meeting. This is the first time Mrs. Bull will miss it."

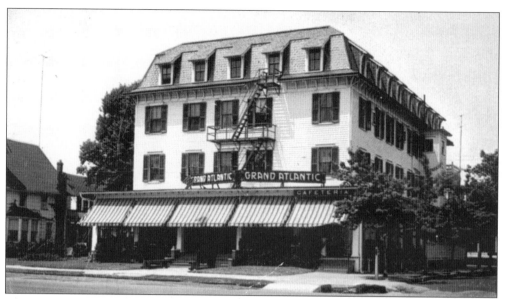

The Grand Atlantic, formerly the United States Hotel, was known for its cafeteria, its 200-person capacity, and its elevator. Located at 21 Main Avenue, the hotel lists M.J. Woodring as proprietor. The fourth-floor mansard roof is typical of Victorian style. The building is now being renovated to be used as a retreat home for a Catholic religious order.

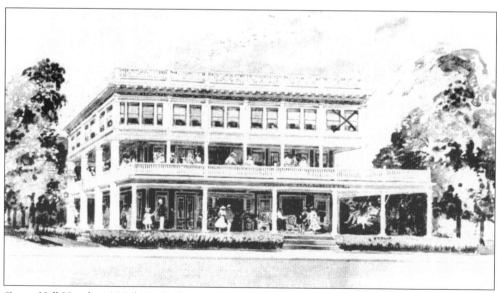

Grove Hall Hotel, at 17 Pilgrim Pathway, was a combination of three structures. In 1995, the place was purchased by the Camp Meeting Association and turned into a retreat and conference center. The message on this card sent to Bethlehem, Pennsylvania, reads, "Awnings and palms improve the appearance of the place very much. X indicates our room—a third window on the side. I should like about a month of this. Margaret and Marjorie Ann are making full use of the ocean."

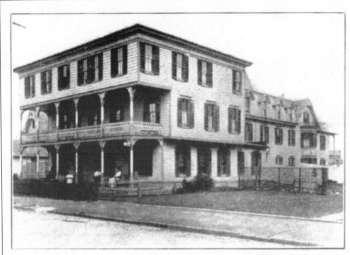

THE PARK VIEW. 23 Sea View Ave., OCEAN GROVE, N. J.

The Park View Hotel, at 23 Sea View Avenue, was operated by Mrs. R.A. Wainwright. This hotel, like many others in town, was originally a ground-level structure. The entire building was raised one level to provide lodging for summer help. With a capacity of 125, this hotel is another example of two cottages being joined together, back-to-back, with a large dining room connecting them.

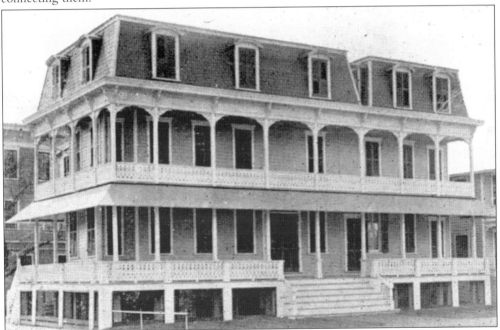

The Buena Vista stands on the southwest corner of Beach and Heck Avenues. This three-story mansard hotel appears to be a joining of two buildings with a break in the third floor. The pent and pipe fence rail are typical of the 1890s. The card was mailed on July 13, 1909, to Mrs. Johnson in Eatontown. "Best Wishes from Ocean Grove, J.B. Willits—formerly of the 'The Bella Laine.'" The hotel, now named the Carriage House, is a bed and breakfast with a reduction in the number of rooms from 16 to 10, all with modern facilities.

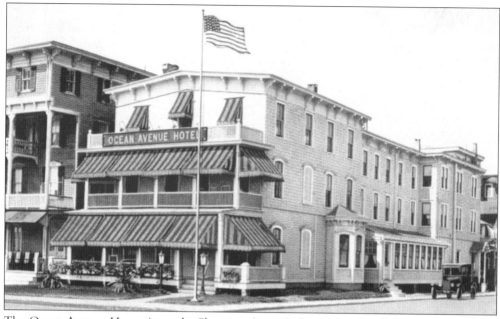

The Ocean Avenue House (now the Shawmont), at 17 Ocean Avenue, features two urns, two stair lamps, and a three-story flagpole on the front lawn. While doing renovations, timbers from a ship were found in two of the bedrooms. During the Victorian era, it was not unusual for builders to salvage materials from shipwrecks along the Jersey coast.

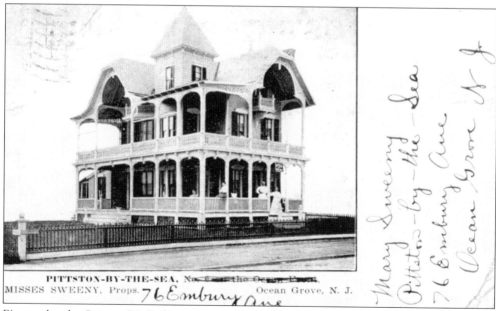

PITTSTON-BY-THE-SEA, Ocean Grove, N. J.
MISSES SWEENY, Props.

Pittston-by-the-Sea, at 76 Embury Avenue, with the Misses Sweeny as proprietors, was a complete Victorian cottage with a tower, shaped lintels, two tiered porches, and a wooden picket fence. The card is addressed to Mrs. W.W. Ker in Mount Tabor: "We hope to see you and Mr. Ker and Florence again this summer as we have better accommodations this year. We have a different house hope to see you again." This building was actually located at 6 Ocean Avenue and is now called the Silver Sands.

Nagle's Pharmacy, located on the northwest corner of Main and Central Avenues, was a year-round drugstore and ice-cream parlor. It is now a 1920s-style restaurant with the summer ice-cream crowd of adults and children patiently standing in line outside waiting for a sweet treat.

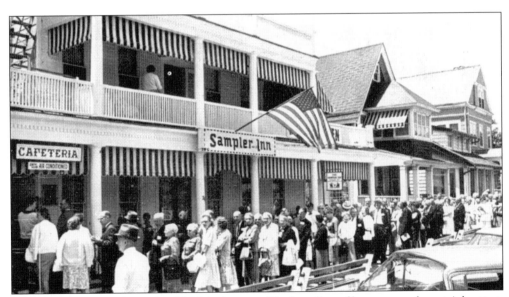

The Sampler Inn was located at 28 Main Avenue. The long line of hungry people certainly attests to the reputation of this cafeteria. The interior walls were lined with both new and old samplers, many donated by satisfied patrons. The macaroni and cheese, lamb shanks, and stewed apples were favorites.

The exterior of 64 Main Avenue has not changed since the building was constructed in 1899 by G.S. Evans, the secretary of the Ocean Grove Camp Meeting Association. The sheet-metal facade has been completely restored by Dr. Dale C. Whilden, who provided this card, the same one he uses to remind his patients of their dental appointments. The building previously served as the Ocean Grove Times office, where the weekly newspaper was printed and assembled.

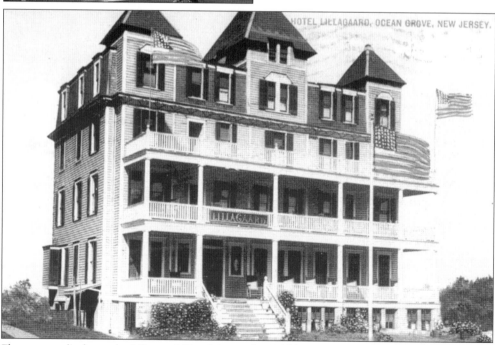

Flags are on display at the Lillagaard Hotel, located at 5 Abbott Avenue. Now a bed and breakfast, this grand old hotel features four stories of theme bedrooms, many of which are reserved as early as a year in advance. The hotel also features an afternoon English tea with freshly baked scones and clotted cream.

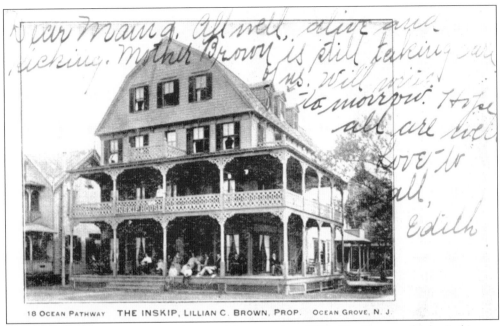

18 OCEAN PATHWAY THE INSKIP, LILLIAN C. BROWN, PROP. OCEAN GROVE, N. J.

The Inskip stands at 18 Ocean Pathway, with a capacity of 100. The Reverend John Inskip was one of the original trustees of the Ocean Grove Camp Meeting Association and a leader in the National Association for the Promotion of Holiness. The hotel, now the Ocean Plaza, has been completely renovated.

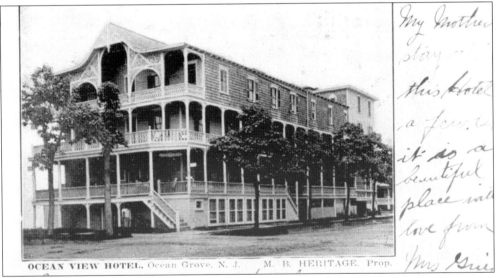

OCEAN VIEW HOTEL, Ocean Grove, N. J. M. B. HERITAGE, Prop.

The Ocean View Hotel was constructed at 43 Broadway in 1881–1882. The hotel had only three owners over its 86 years of operation: William A. White and daughter Louisa Pridham, from 1881 to 1935; Leon K. Beidler, from 1935 to 1961; and Dieter Tippe, from 1961 to 1967. The hotel had a raised brick basement—a necessity due to the road flooding at Broadway and Central Avenue. The 1871 map of Ocean Grove shows Carvosso Lake in the middle of Broadway and Central Avenue. In 1967, the hotel was razed for the purpose of constructing three modern homes, one to face Broadway, one on Central Avenue, and one on Abbott Avenue.

These two red lobsters would certainly fill the plate of a hungry vacationer. The words "Ocean Grove" could be changed to Asbury Park or any other shore town that might order the card. This card was made in Germany, published by the Illustrated Postal Card Company of New York, and mailed in 1908 to British Columbia, Canada.

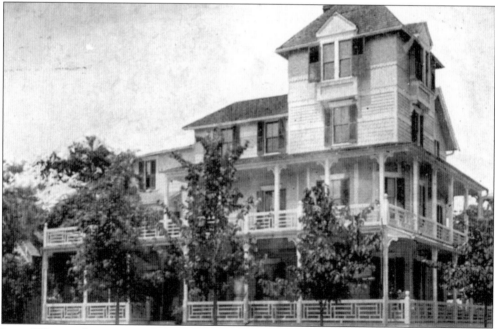

Lane Villa stands at 63 Cookman Avenue, an example of late-Victorian exuberance with a massive tower, wide porches, and column trim. The proprietors were M.L. and L.A. Lane, and the capacity was 60. The message on the card reads, "Many thanks for your pretty church view. I now have near one thousand church views. I have over 5 thousand postal in my collection. Hope you will like this card and come again. Ida."

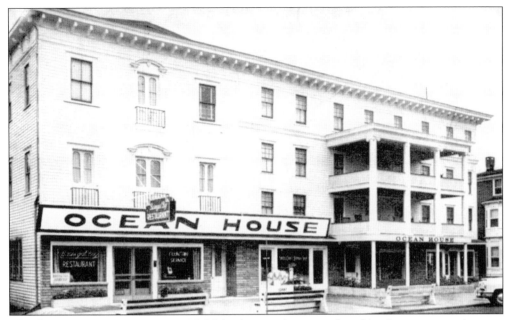

The three-story Ocean House, at 72 Main Avenue, is now reduced in size to two stories over the sign "Ocean" and one story for the rest of the facade. The Shell Shop is located in the part with the "House" sign, and a new restaurant, Captain Jack's, occupies the "Ocean" half.

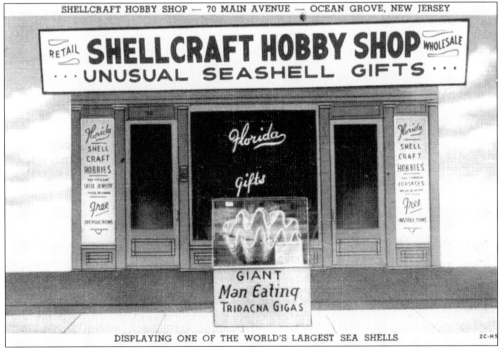

On Main Avenue, the Shellcraft Hobby Shop exhibited a giant man-eating clam from a coral reef in the South Pacific Ocean. It took three days to loosen the clam from the coral bed where it had grown. The specimen measures 40 inches long, 30 inches wide, and 26 inches high. The lower half of the clamshell can be seen today in the window of the Shell Shop.

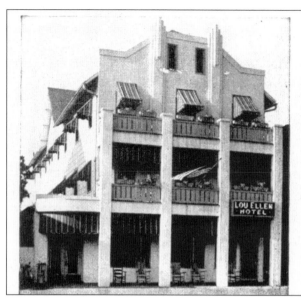

Lou=Ellen Hotel

58 MAIN AVENUE
(Opp. Postoffice)
OCEAN GROVE
N. J.

Private Showers
All Outside Rooms
Hot and Cold Water
in Rooms

Phone A. P. 2-8549

ELSIE R. GRAHAME, Mgr.

The Lou Ellen Hotel, at 58 Main Avenue (opposite the post office) advertised private showers, all outside rooms, and hot and cold water in the rooms. The telephone number was AP 2-8549. Elsie R. Grahame was the manager. The Art Deco stucco facade replaced normal Victorian extravaganza.

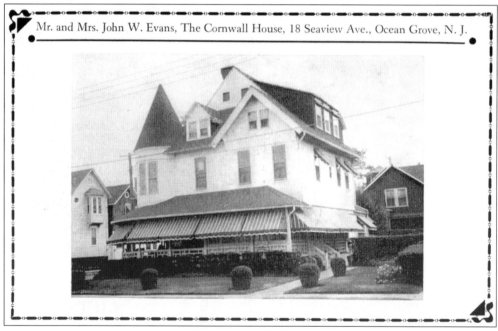

Mr. and Mrs. John W. Evans, The Cornwall House, 18 Seaview Ave., Ocean Grove, N. J.

The Cornwall House, at 18 Sea View Avenue, offered furnished rooms. It was not unusual for 15,000 to 20,000 people to be in residence in Ocean Grove during the summer season of the Camp Meeting Association. Many homes were converted to "Furnished Room Establishments." Mr. and Mrs. John W. Evans advertised their home with hot and cold water, open all year, with heated rooms. Many new Ocean Grove homeowners now ask about the small white iron sinks in each room, not realizing that they have purchased a seasonal rooming house. A duplicate of this house is at the corner of Abbott and Beach Avenues.

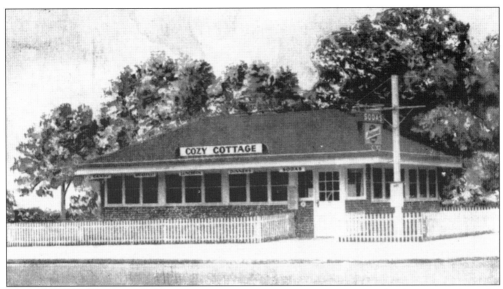

Many of the people who are active in the Ocean Grove community today have been here for generations. Among them are the Keatings, whose restaurant, the Cozy Cottage, at 35 Pilgrim Pathway, is now a two-story professional office building.

"When you think of eating think of Keating" is another catchy phrase that would remind hungry patrons of this restaurant. This card went to Mount Joy, Pennsylvania, with the message, "Alice send your receipt for canning corn for mother. We expect little Geo. Today if it don't rain. I was out to a birthday party last night. Yours, HKM."

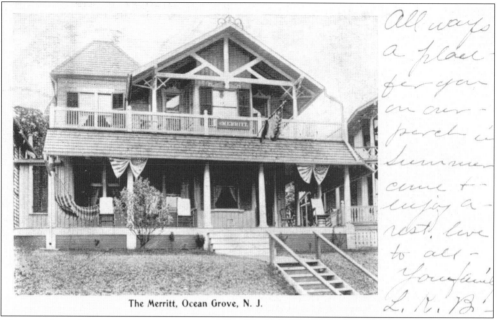

The Merritt, Ocean Grove, N. J.

The steeply inclined stairs identify the location of this house, the Merritt, on Lake Avenue. The American flag, patriotic bunting, porch rockers, and fringed hammock add to the written message: "All ways a place for you on our porch in summer. Come and enjoy a rest. Love to all your family. L.K.B." On the correspondence address side: "How do you like these cards? We are much pleased, just need you." The card was mailed to Ashley Falls, Massachusetts, on December 23, 1907. Many hotel owners would send cards to former guests inviting them to come back in the upcoming season.

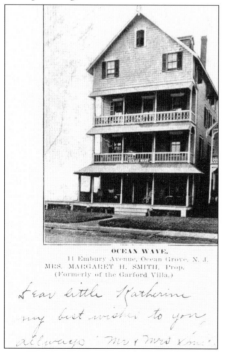

OCEAN WAVE.
11 Embury Avenue, Ocean Grove, N. J.
MRS. MARGARET H. SMITH, Prop.
(Formerly of the Garford Villa.)

The four stories of this hotel must have represented a formidable climb for any vacationer. The Ocean Wave, at 11 Embury Avenue, was run by Margaret H. Smith, proprietor, who was formerly of the Garford Villa. The message on this card, sent to San Jose, Costa Rica, states, "We are having a fine day for our excursion. Had a fine ride down in a big bus. We did not come by train this time. I have not been in bathing yet today. May not go in. I have no bathing partner today."

116

THE WRIGHT CORNER IN OCEAN GROVE, N. J.
104 HECK AVENUE — PHONE 775-6219
— OPEN ALL YEAR —
MRS. ALICE G. HOLT — OWNERSHIP-MANAGEMENT

The Wright Corner, at 104 Heck Avenue, is typical of catchy phrases that attract visitors to a small, intimate boardinghouse. The card's message reads, "My dear Nettie, Can't you come here with me this week? Take the trolley to Newark. Penn. Railroad Station train comes to Ocean Grove, late stage at station to my house [a 10-minute ride for 10¢]. Drop me a line. It is beautiful down here. JR."

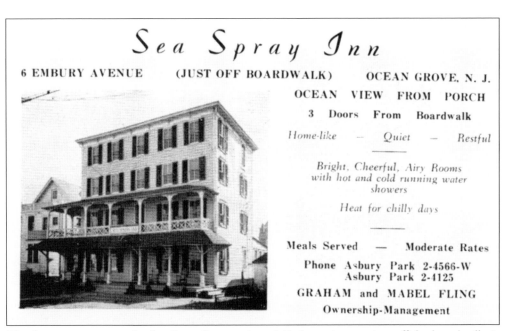

Sea Spray Inn

6 EMBURY AVENUE **(JUST OFF BOARDWALK)** **OCEAN GROVE, N. J.**

OCEAN VIEW FROM PORCH

3 Doors From Boardwalk

Home-like — *Quiet* — *Restful*

Bright, Cheerful, Airy Rooms
with hot and cold running water
showers

Heat for chilly days

Meals Served — Moderate Rates

Phone Asbury Park 2-4566-W
Asbury Park 2-4125

GRAHAM and MABEL FLING

Ownership-Management

The four-story, rectangular Sea Spray Inn stands at 6 Embury Avenue just off the boardwalk. It advertises an ocean view from the porch, "home-like—quiet—restful—with bright, cheerful, airy rooms, with hot and cold running water, showers, and heat for chilly days," also "meals served—moderate rates." The hotel has shutters and a pent that separates the first and second porches.

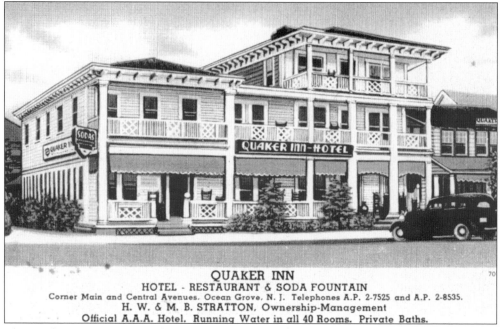

QUAKER INN
HOTEL - RESTAURANT & SODA FOUNTAIN
Corner Main and Central Avenues, Ocean Grove, N. J. Telephones A.P. 2-7525 and A.P. 2-8535.
H. W. & M. B. STRATTON, Ownership-Management
Official A.A.A. Hotel. Running Water in all 40 Rooms. Private Baths.

The Quaker Inn, at Main and Central Avenues, advertises "the Perfect Location for a Grove Vacation." The card was sent to the YMCA in Scranton, Pennsylvania. Its message reads, "Hello Mr. Lewis. This is the place I work. Am night clerk. Great job. Working for fine people and making good. How is everything in the cool regions? There are about 30 P.S. people in this town so you see I am having the time of my life."

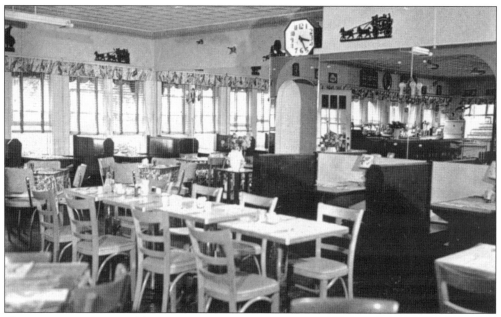

Shown is a partial view of the restaurant and soda fountain at the Quaker Inn. The Quaker style is reflected in the stagecoach wall hangings.

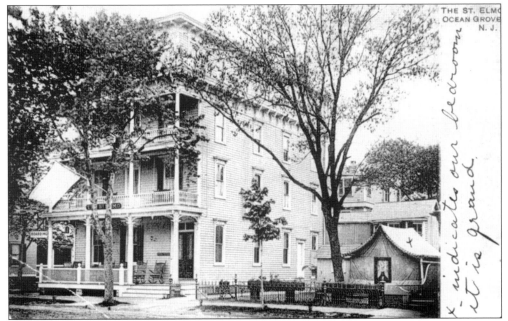

With a capacity of 65, the St. Elmo stands at 77 Main Avenue, with Mrs. William Jones as proprietor. A comparison of this card with the present building shows that the hotel was expanded to the right (two bays wide and four stories high). The *x* confirms that sleeping in a tent does give one a good night's sleep.

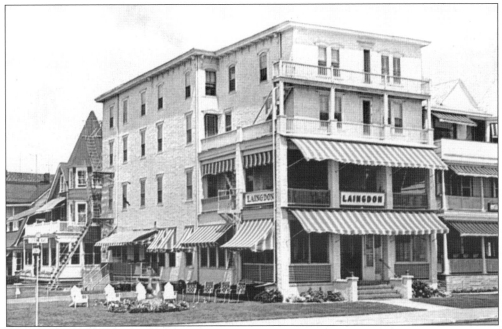

The Laingdon, at 8 Ocean Avenue, is another example of a combination of two buildings. This hotel at one time had a meditation room with a cross and an altar. Another feature is the outside fountain with a seal in the center. The hotel has recently undergone $1 million restoration funded in part by a state and federal grant for use in historic districts.

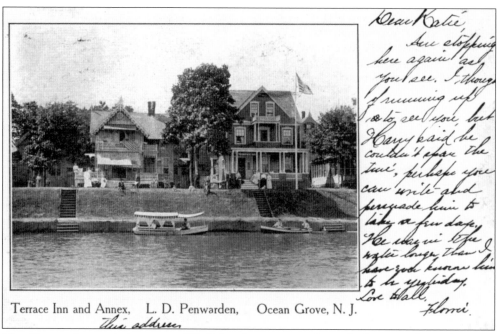

Terrace Inn and Annex, L. D. Penwarden, Ocean Grove, N. J.

The Terrace Inn and Annex, at 108 Lake Avenue, was located along Wesley Lake. L.D. Penwarden is listed as proprietor. The Annex appears to be the older of the two houses, judging from the style. Women in long white dresses can be seen on both porches, perhaps trying to decide if they want to take a ride in the covered rowboat. The message on the card says, "Dear Katie, We are stopping here again as you can see. I thought of running up to see you but Harry said he couldn't spare the time. Perhaps you can write and persuade him to take a few days. He was in the water longer than I have. You know him to be yielding. Love, Hall." Note the beautiful penmanship.

Interior views are hard to find. This one shows the Terrace Inn parlor, furnished with an upright piano with a round stool, a platform rocker, rattan chairs and tables, a leaded lamp, a settee, pillows, and pictures—all qualifying as today's antiques.

The Sheldemeer was located at 95 Main Avenue, with Anna M. Helwig as proprietor. The card went to Allentown, Pennsylvania, with this message: "This is our home. Having a good time & well. Wish you could be with us."

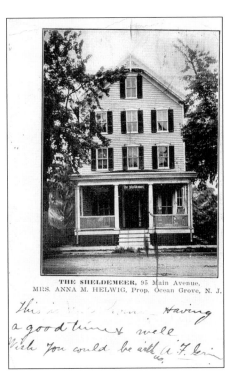

The Sheldon House occupied 10 lots from Surf Avenue through to Atlantic Avenue to the corner of Central Avenue. It was advertised as having gas throughout, bathrooms with hot and cold water, closets, ventilators, spring beds, and good mattresses in every room. A force pump with hose was arranged to carry water to every part of the building in case of fire. The cupola provided a magnificent view of the entire coast from Long Branch to Spring Lake. The Founders Memorial Urn is to the right in the park.

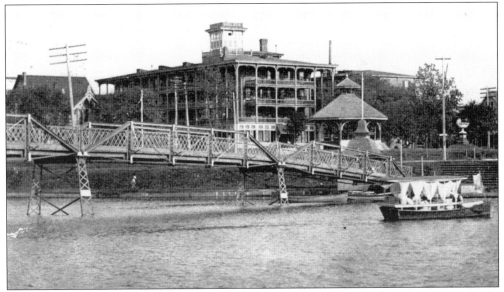

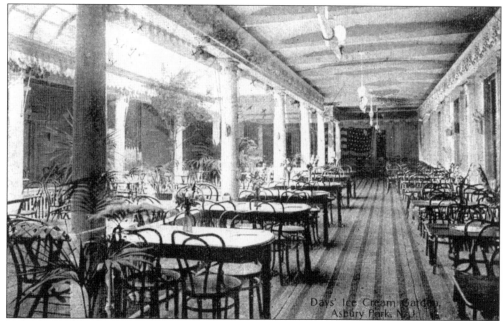

Day's Ice Cream Parlor is shown with the original bentwood chairs and walnut tables. A new restaurant, the Starving Artist, has been added to the ambiance of this 100-year-old-plus establishment. This card was sent to Keene, New Hampshire, with this message: "Dear folks, We are all here eating ice cream and having a nice time, only wish Perry was here too. Love to all."

This postcard, showing Pathway Manor, on Ocean Pathway, was sent to Miss D.E. in Jersey City with the following message: "The Radio Taxi, Cookman Ave., Asbury Park, NJ, has a bag with bathing suits. Please contact them, describing the contents. We could not describe the contents. Very truly yours, MHB."

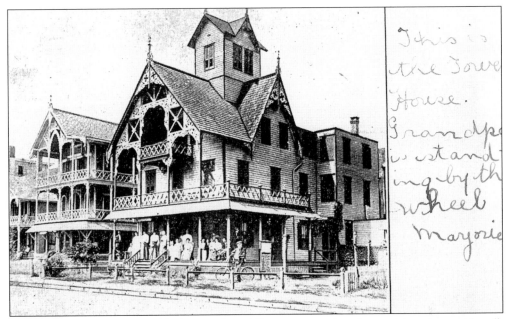

The Tower House, at 27 Webb Avenue, has a 75-person capacity, slate curbing, a grass sidewalk strip, and detailed vargeboard throughout. This card, sent to Andover, Massachusetts, in 1906, contains a brief message: "This is the Tower House. Grandpa is standing by the wheel. Marjorie."

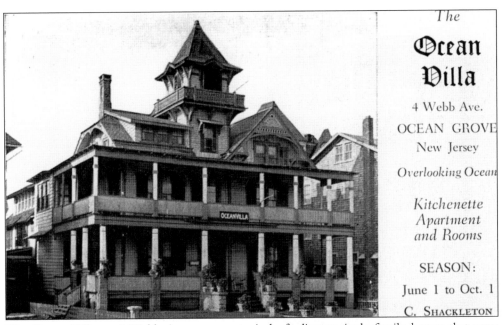

The Ocean Villa, at 4 Webb Avenue, was typical of adjacent single-family homes that were joined together into one large hotel. Rooms were added wherever possible in the form of dormers and enclosed porches. The Villa was torn down in 1985. The cupola was removed by a crane and relocated in Auditorium Park, where it serves as a garden tool storage shed.

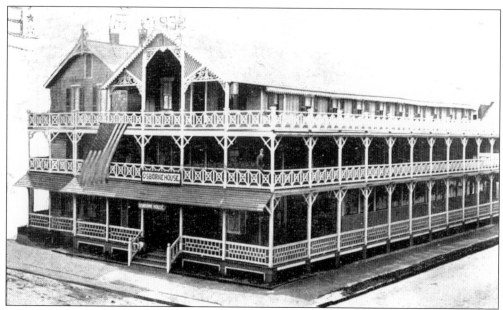

The Osborne House was located at the center of the town, at the southwest corner of Central and Pitman Avenues. The spelling of Osborne with an *e* at the end raises the question as to whether there is any connection to the founder of Ocean Grove, the Reverend William B. Osborn. The two joined buildings illustrate the typical expansion of a good hotel.

Hotel cards were a popular means of advertising an establishment. The reverse side of this card extolled the hotel's virtues. "This Established House is pleasantly situated in the coolest part of the Grove, being near the Ocean, Camp and Bathing Grounds and Post-Office, and is invariable patronized by its former Guests. No pains will be spared in ministering to their comfort and in sustaining the excellent reputation of the Table, and with recent improvements in Bed Rooms, Dining Hall and Reception Rooms, we hope to be able to please all." Children under 12 years were half price; table board was $1 per day; dinner was 50¢. The hotel, which was open June 25 through September 15, had a piano for use by the guests, and correspondence was promptly attended to by proprietor James H. Goodwin.

Aug 31
1907

Greetings
from
Asbury Park and
Ocean Grove,
N. J.

U.S
MAIL

M. E. P.

Letter Carrier Series Copyrighted 1907, and Pat. appl. for by Franz Huld, Publisher, N. Y.

All of the cards that are pictured in this book were delivered by the U.S. Postal Service.

Appendix

OCEAN GROVE

POSTCARD PUBLISHERS

3-Starr Press, Masonville, Iowa.

A. Borden; printed in Germany.

Abingdon Press, New York, Cincinnati, Chicago.

Acme Print, 612 Second Avenue, Asbury Park 4444.

American News Company, New York, Leipzig, Berlin, Dresden.

American Post Card Company, Toms River, New Jersey.

Americhrome, Leipzig, New York, Berlin; printed in the United States.

Arrow Advertising Specialty Company, West Allenhurst, New Jersey.

Arthur Livingston, Publisher, New York.

Artvue Post Card Company, 225 Fifth Avenue, New York.

B.P.C. Company, 815 Broadway, New York; printed in Germany.

C.A. Brown, Ocean Grove, New Jersey; made in Germany.

Eagle Post Card Company, New York.

F.A. Von Wieding, Boardwalk, AP.

F.S. Morris & Company, Ocean Grove, New Jersey; printed in the United States.

Franz Huld Company, New York; Eagle Series.

Gail Greig, Greig Cards, 117 Cookman Avenue, Ocean Grove, New Jersey.

Hartmeier Company, Paterson, New Jersey.

Heath's Casino Bazaar, Boardwalk, Asbury Park, New Jersey; Germany.

Hustler Printing Company, 603 Main Street, Asbury Park, New Jersey.

I & M Ottenheimer, Baltimore, Maryland.

I. Stern, Brooklyn, New York.

Illustrated Postal Card Company, New York, Germany.

Illustrated Postal Card Company, New York, Germany, Leipzig.

Industrial Photo Service, Oakhurst, New Jersey.

J. Murray Jordan, Publisher, 1438 South Penn Square, Philadelphia.

J.T. Wilcox, 1907.

K.V.G.G. Lange - L—Schwalbach.

Leighton & Valentine Company, New York City; printed in the United States; made in Germany.

Navesink Publishing Company, Box 124, Red Bank, New Jersey.

NPC Studios, Avon-by-the-Sea, New Jersey.

Ocean Grove Historical Society.

Parlin Color Company, Toms River, New Jersey.

Parlin Color Company, Toms River, New Jersey, and Boynton Beach, Florida.

Pontier Brothers, 258 Mount Prospect Avenue, Clifton, New Jersey 43307.

Rao Vris Advertising, Hoboken and Ocean Grove, New Jersey.

Rosin & Company, Philadelphia and New York; made in Germany.

Rotograph Company, New York City; Germany.

SL Company, Germany.

Samuel Strauss Company, Brooklyn, New York.

Souvenir Post Card Company, New York; printed in Germany.

Star Stationary Company, Newark, 64 Howard Street, Irvington, New Jersey.

The Post Card Distributing Company, Philadelphia.

Theodore E. Shulte, Publisher, Asbury Park and Ocean Grove, New Jersey.

Times Printing House, 10¢ a dozen, 12¢ by mail.

Ullman Manufacturing Company, New York.

Union Distributing, Red Bank, New Jersey.

Union New Company, New York, Dresden, Leipzig, Berlin; made in Germany.

Valentine & Sons Publishing Company, New York and Boston; printed in Great Britain.

W.H. Bechiel, Asbury Park, New Jersey; made in the United States.

W.G. Kress, 1905.

Featured in this montage are some hallmarks of postcard publishers.

BIBLIOGRAPHY

Ayres, S., and G.S. Crawford. Images of America *Bradley Beach*. Arcadia Publishing, 2002.

Bell, W.T. Images of America *Ocean Grove*. Arcadia Publishing, 2000.

Daniels, M.S. *Story of Ocean Grove*. New York: the Methodist Book Concern, 1919.

Gibbons, R.F., and F. Gibbons. *History of Ocean Grove, 1869–1939*. Ocean Grove, New Jersey: Ocean Grove Times, 1939.

Flynn, C. *The Carousels of Wesley Lake,* the Carousel News Trader, 1999.

Goodrich, Peggy. *Four Score and Five: History of the Township of Neptune. 1976.*

Griffith, A. Map of Ocean Grove.

History of Ocean Grove, New Jersey, 1869–1944. Ocean Grove, New Jersey: Ocean Grove Camp Meeting Association, 1944.

Jones, C.E. *Perfectionist Persuasion: The Holiness Movement and American Methodism, 1867–1936*. Metuchen, New Jersey: Scarecrow Press, 1974.

Lewis, E.S. Images of America *Neptune & Shark River,* Arcadia Publishing, 1998.

Messenger, Troy. *Holy Leisure*. University of Minnesota Press, 1999.

Ocean Grove Camp Meeting Association. Annual Reports, 1870–1919. Ocean Grove, New Jersey.

Osborn, W.B. *Pioneer Days of Ocean Grove*. The Methodist Book Concern, New York.

Progressive Citizens League of Asbury Park. *The Story of Asbury Park, 1916–1931.*

Schwartz, William N. *E. H. Stokes Fire Company 1886–1961*. Ocean Grove, New Jersey.

Shaw, John R., and G. Hoffmeier. *The Great Auditorium Organ*. Ocean Grove, New Jersey: Ocean Grove Camp Meeting Association, 1995.

Smith, F.A. *Memories of Ocean Grove—Recollections of an Octogenarian,* K. Chambers and R. Steward, editors. Historical Society of Ocean Grove, 2002.

Wood, J. *Collector's Guide to Post Cards, 1995.*